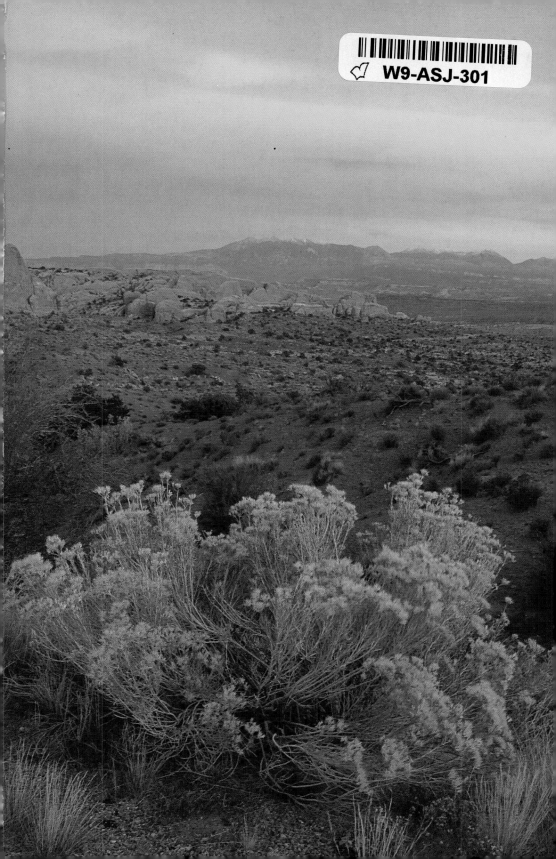

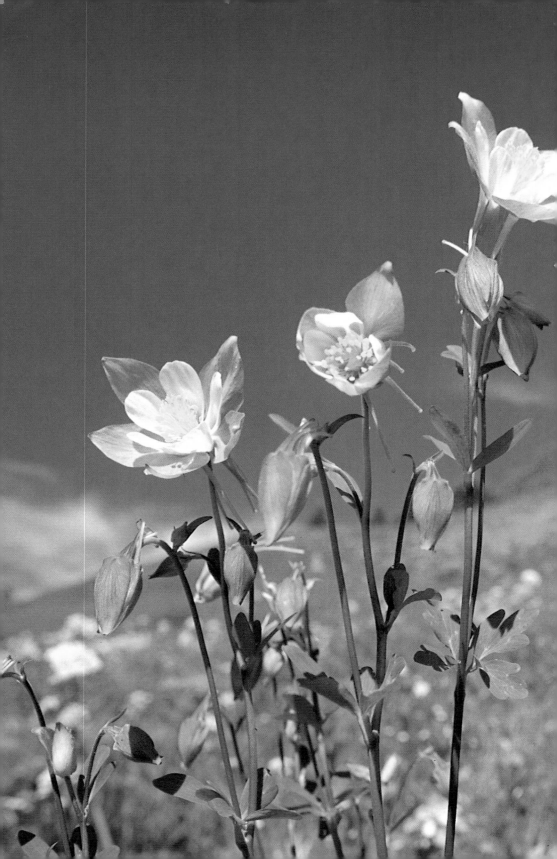

THE FIELD GUIDE TO PHOTOGRAPHING

THE SEASONS

CENTER FOR NATURE
PHOTOGRAPHY SERIES

ALLEN ROKACH
AND
ANNE MILLMAN

AMPHOTO BOOKS
AN IMPRINT OF WATSON-GUPTILL
PUBLICATIONS/NEW YORK

To Roly and Marcelo

for their spiritual guidance

in every season.

PICTURE INFORMATION:

Page 1: Sunset overview. Monument Valley, Utah.

Pages 2-3: Columbines. Crested Butte, Colorado.

Page 5: Fungi and fallen leaves. The New York Botanical Garden, Bronx, New York.

Page 6: Lupines. Acadia National Park, Bar Harbor, Maine.

Senior Editor: Robin Simmen
Editor: Liz Harvey
Designer: Bob Fillie, Graphiti Graphics
Graphic-production Manager: Hector Campbell

Text by Allen Rokach and Anne Millman, co-founders of the Center for Nature Photography (3916 Glenwood Avenue, Birmingham, AL 35222; 205-595-5665)
Photographs by Allen Rokach

Copyright © 1998 by Allen Rokach and Anne Millman
First published 1998 in New York by Amphoto Books,
an imprint of Watson-Guptill Publications,
a division of BPI Communications,
1515 Broadway, New York, NY 10036

Library of Congress Cataloging in Publication Data
Rokach, Allen.
 The field guide to photographing the seasons/by Allen Rokach and Anne Millman.
 p. cm. — (Center for Nature Photography series)
 Includes index.
 ISBN 0-8174-3875-0
 1. Photography of trees. I. Millman, Anne. II. Title.
III. Series: Rokach, Allen. Center for Nature Photography series.
TR659.5.R65 1998 97–46886
778.7'1—dc21 CIP

Manufactured in Singapore

1 2 3 4 5 6 7 8 9/06 05 04 03 02 01 00 99 98

ACKNOWLEDGMENTS:

Many people helped make this book a reality. We will always appreciate the encouragement Mary Suffudy gave us when she was at Watson-Guptill. Without her support, this series of field guides could not have been launched. We also thank Liz Harvey, our editor, for guiding us and improving our efforts with patience, sensitivity, and skill.

A number of people at Olympus America, Inc., have been consistent supporters of our enterprises. We thank in particular Marlene Hess, Manager, Public Relations; Dave Willard, Vice President, Marketing Communications; and John Lynch, Group Executive Vice President, for their generosity in providing equipment, technical advice, and funding that enabled us to prepare nearly all the images in this book.

We owe a special debt of gratitude to a number of organizations for their travel assistance to Holland. Thanks go to Odette Fodor of KLM Royal Dutch Airlines, and Barbara Veldkamp and Eline van Bon of the Netherlands Board of Tourism.

A word of appreciation goes to John Floyd, editor of *Southern Living* magazine, for granting permission to reproduce images in this book that were originally taken for that publication.

Finally, we want to acknowledge some friends and fellow photographers who pointed us in the right direction on many occasions, often joining us in the field and helping us with their advice, criticisms, and suggestions: Dan Norris, Jan Runge, Jim Steinberg, Frank Kecko, and David Ferguson.

Contents

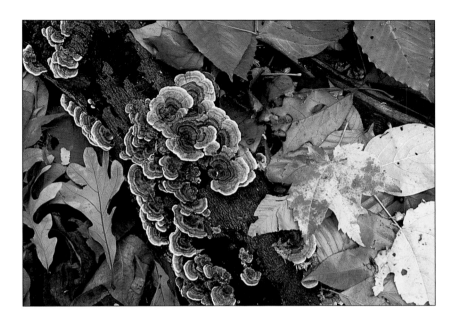

INTRODUCTION 6

CHAPTER 1: REDISCOVER THE SEASONS 8

CHAPTER 2: TOOL UP 28

CHAPTER 3: COMPOSE WITH CLARITY 70

CHAPTER 4: SEASONAL COLORS 84

CHAPTER 5: THE LIGHT FANTASTIC 96

CHAPTER 6: SEASONAL SIGHTINGS 118

INDEX 128

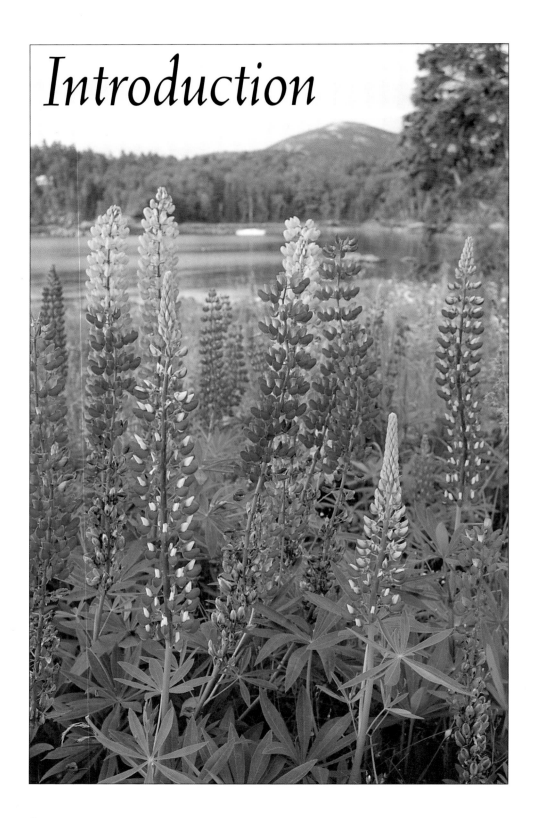

Introduction

The seasons have been a muse to poets, composers, and artists through the ages. The seasons have inspired ordinary people as well. They are the visible markers of time, exhorting people to sow or reap, to swim or ski, to drink hot cocoa or iced tea, even to fall in love. Those of you lucky enough to live where the seasons are palpable might love them or resent them, but you surely can't ignore them. They dominate your activities and force you to take notice, especially in the realm of chores. You pack away boots and parkas, install window screens, clean off the barbecue, order insulation, rake leaves, and so on. Perhaps you make time for a drive in the country to view fall foliage or for a visit to a botanical garden to see the summer roses, or perhaps a holiday celebration anchors your experience of each season.

But how many people truly plumb the depths of what each season has to offer? How many people look closely and carefully at the subtle changes that nature unfolds as each season arrives? How many people ponder their own shifting moods as the seasons make their yearly passage? And how many people, like the poets, find in the seasons a reflection of the very transience of their lives: a time for hope and a time for fear, a time for joy and a time for grief?

What does all this have to do with photography? Quite a lot. Photography isn't just about making pretty pictures. At its best, it is about communicating through images, about projecting an individual vision onto what you see, and shaping that vision so that others will understand and appreciate it.

When photographing the seasons, you want to go beyond portraying what you already know and begin to explore what you don't yet know— about the world of nature and about yourself. The fundamental truth that the seasons reveal to is that you are part of nature. You don't only want to look at nature and say how lovely it can be. You want to look at nature and find a meaningful connection to it in your life.

Of course, the potential for beauty in the nature's cycle of seasons is undeniable and remains a potent source of our attachment to it. People marvel despite themselves at the fresh green of a glorious spring day. They're swept off their feet by the fiery yellows of an aspen grove in autumn. As a photographer, you must challenge yourself to portray these recurrent natural events so that they convey a fresh wonder and passion. And if you let yourself explore more deeply and intensely, you can also discover the less apparent beauties of the seasons—not just the glorious and majestic sides, but the hidden loveliness that only a sensitive eye can bring to light. We hope this book will guide you on that kind of journey through the seasons.

ANNE MILLMAN

CHAPTER 1

Rediscover the Seasons

Practice near home in order to learn how to turn the flow of a waterfall milky white via a slow shutter speed. In this shot taken in Great Smoky Mountains National Park in Tennessee, the dim, diffused light of an overcast spring day made a long exposure easy to get. Shooting with a Zuiko 28mm lens, I exposed Ektachrome 100 SW for 1/4 sec. at f/22.

You can discover simple closeups like this shot of white marsh marigolds amid deep green summer foliage almost anywhere. Dim, diffused light helped me obtain good exposure in this high-contrast situation. Working with a Zuiko 90mm macro lens in Crested Butte, Colorado, I exposed at f/11 for 1/15 sec. on Fujichrome Velvia.

The seasons are so much a part of the ebb and flow of people's lives that it is easy to forget to notice them. This isn't to say that people aren't aware of which season it is. But they can become inured to the special joys each season brings. In spring, people walk past trees whose tiny flowers are suspended overhead, oblivious to them until their seeds are blown in the wind. In autumn, people see the falling leaves but don't stop to admire the fine form of a bare tree. Their connections can surely be stronger.

All your senses can connect to seasonal changes: you feel hot or cold;
you hear the sounds of birds, the wind, and footsteps on fresh snow; you
smell flowers and cut hay; and you taste wild berries and crisp apples.
But your sense of sight can fling open windows and doors to the natural
world, stimulating your interest in photography. However, many people
live at a distance from nature or are so involved in activities that turn
them inward, that they must learn anew how to be sensitive to the
wonders of each season.

SENSITIZE YOUR EYE

So often in our workshops one person will stop to look at something
while others have passed it by. Why is that? What enables one photogra-
pher to see a fitting subject while others notice nothing significant? And
can this ability to notice be learned? It certainly can. Here are some ways
to begin looking at each season with a sense of freshness and discovery.

Get out of your rut or routine. For example, take a different route to
work, whether you're driving or walking. Being in a new situation often
compels people to look more intently.

Change your habits. If you wake up and immediately hop into the
shower, start by looking outside. Observing the same tree or yard every
day enables you to see changes from one day to the next, especially if
you consciously look for those differences. Notice the changing foliage,
from first buds to fallen leaves, or identify the birds that visit in each sea-
son, and determine whether they belong to resident or migratory species.

Slow down. Walk whenever you can, and look around as you do.
You'll notice things you never saw before. An excellent way to accom-
plish this is by taking a young child with you. Children stop often to
look closely at something that catches their fancy. Let the child take the
lead, and you won't be in such a hurry. You'll also discover that the jour-
ney has its own rewards and that the fastest route to a destination isn't
necessarily the best one.

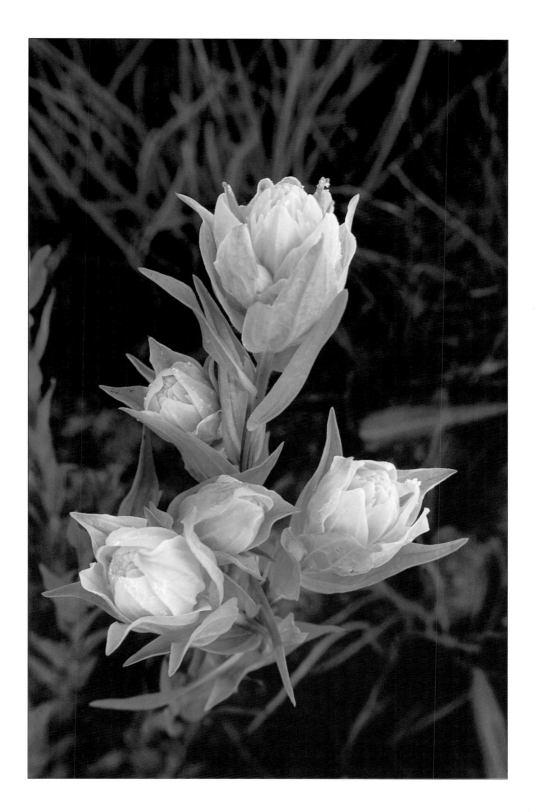

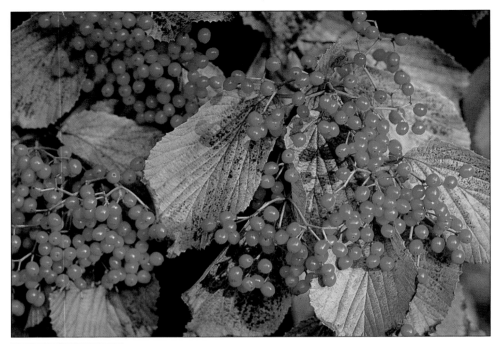

Fall berries on this viburnum shrub at Wave Hill in the Bronx, New York, are a common and colorful sight, although photographers often overlook them. Shooting with a Zuiko 50mm macro lens, I exposed at f/16 for 1/60 sec. on Kodachrome 25.

A telephoto lens can transform an unremarkable hillside of bare trees, like these aspens in Steamboat Springs, Colorado, into an interesting textural abstraction of an autumn landscape. Here, I used a Zuiko 50-250mm lens set at 250mm and exposed for 1/250 sec. at f/8 on Fujichrome 100.

Keep a journal. You'll be surprised by how much more you notice when you write down your observations. Scientists develop the note-taking habit not just to remember what they saw but to actually see more. When you photograph, taking notes helps you keep track of what you were trying to shoot. Include your thoughts and feelings as well as descriptions and lists of things you saw.

As you develop better habits of seeing, start taking your camera along. Chances are you'll want to shoot new kinds of pictures. If not, try very hard not to repeat yourself, even if you have to force yourself to do something different with the same subject. For example, shoot from another perspective or work with a different lens. Experiment, even if the results aren't always successful. Sensitizing your eye is a preliminary step toward effectively portraying the seasons.

SEE PHOTOGRAPHICALLY

Learning to see photographically comes next. As much as you wish it were so, cameras won't automatically translate what you see into a photographic image. You have to do the work of translation because camera equipment doesn't "see" the way your eyes see. In addition, you might have an image in mind that interprets what your eyes see, and you begin to understand the need to see photographically.

To do this, you must understand the technical elements that work together in complex relationships to serve your vision. By controlling these elements with skill, you can produce images that your eye wouldn't ordinarily see. For example, through photography you can regulate depth of field so specific areas of an image are in sharp focus and others aren't. You can get extremely close to flowers and insects and photograph them at full life-size on the film frame with a macro lens. This lets you capture aspects too small and hidden to be apparent to the unaided eye, such as pistils, stamens, pollen grains, antennae, and eyes. Then when these images are enlarged in printing or in slide projections, they're magnified

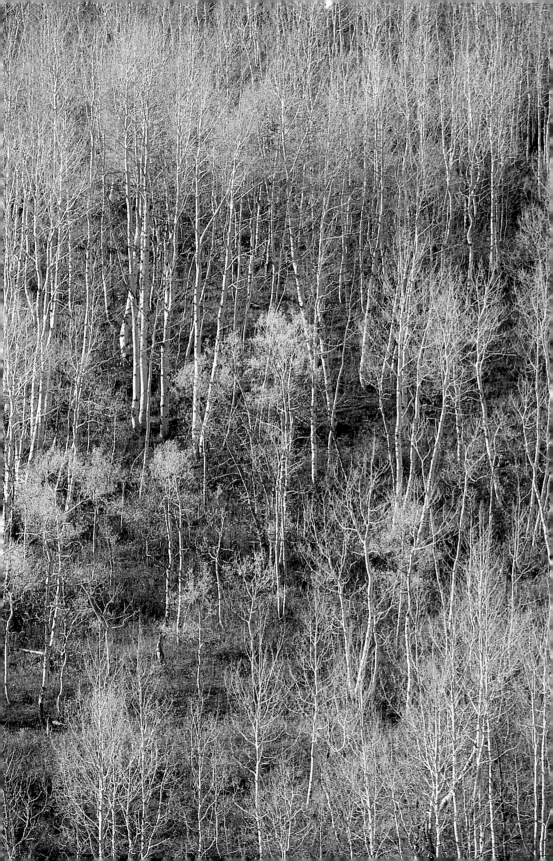

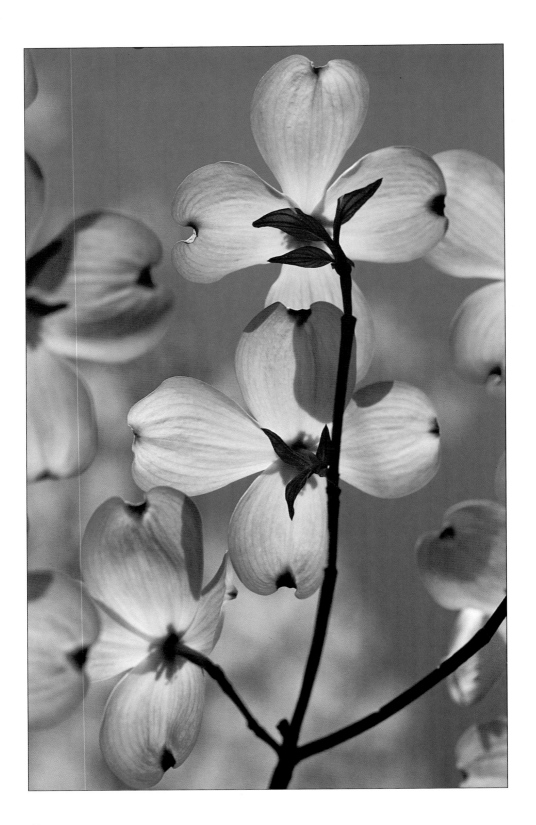

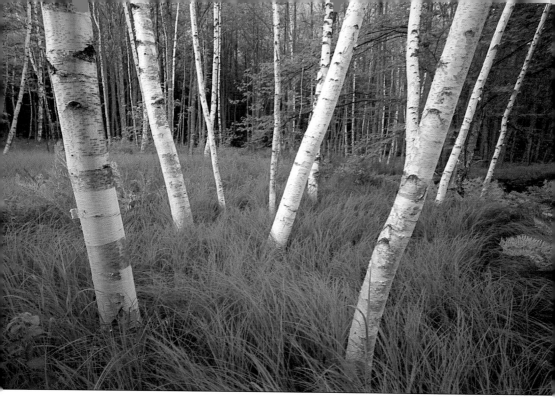

many times. This, in turn, lets you see these details more clearly. Another possibility is to vary the graininess of an image, creating impressionistic effects or super-sharp ones that exceed anything the eye would see.

Automatic camera features can balance these elements in a generic way and produce a reasonably good photograph, better than most unskilled amateur photographers can take. But only a conscientious and mindful photographer can direct those elements with the kind of precision that can produce a truly outstanding nature photograph.

This is the creative dimension of nature photography. The clearer your understanding of what camera equipment can do, the more you realize that you aren't limited to what your eye encounters. The visible world of nature then becomes the resource from which you mine your images. But to unleash your creative powers as a photographer, you need to master using your tools in order to shape and polish that raw material into visual gems.

KNOW YOUR PURPOSE

Knowing what the equipment can do is an essential part of mastering the craft of photography (see Chapter 2). Knowing what you want to do with that craft is the art of photography. Once you've trained your eye to be more observant, you have to find the best way to develop a clear sense of purpose in your photography.

In our workshops, we've met many serious amateur nature photographers. We know how serious they are because they carry a vast array of expensive camera equipment with them on shoots. They clearly have a commitment to their photography. Too often, though, these same photographers have little or no idea about what they actually want to do with their equipment. It is as if they're driving a state-of-the-art vehicle but have no idea where they want to go. But in photography, you must know where you want to go.

Backlight, an unusual perspective, and polarization on the sky can turn ordinary spring subjects like these pink dogwood brachts into special images. Shooting in New York with a Zuiko 90mm macro lens, I exposed at f/4 for 1/250 sec. on Fujichrome Provia.

A telephoto lens can isolate a portion of a scene, as in this shot of a lush summer birch grove at Acadia National Park in Bar Harbor, Maine. A small aperture setting and careful focusing ensured sharpness throughout. Working with a Zuiko 50-250mm lens set at 100mm, I exposed Fujichrome 100 for 1/30 sec. at f/11.

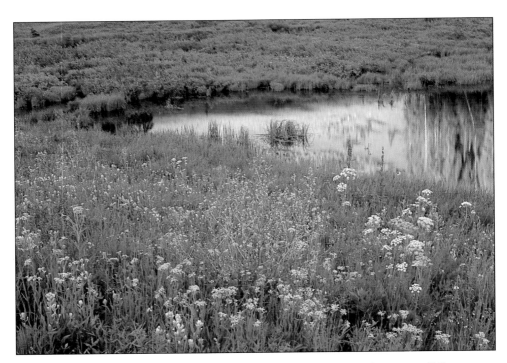

For this summer landscape, my purpose was to document the beautiful glow of low-angled sunset light on a marsh meadow near Crested Butte, Colorado. With a Zuiko 35-70mm lens set at 35mm, I exposed for 1/30 sec. at f/11 on Agfachrome 50.

A telephoto lens helped create an aesthetic abstraction using the colors of spring wildflowers and three posts in a Texas field. Here, I used a Zuiko 50-250mm lens set at 200mm and exposed at f/8 for 1/8 sec. on Fujichrome 100.

Ultimately, every individual seeks a unique destination. Call it your signature, your style, or your vision. Even the kinds of subjects you choose to photograph, whether they are magnificent land forms or tiny plant structures, become part of your signature. In other words, what makes your images distinctly yours? If you think about any creative endeavor—painting, sculpture, music, writing, directing, or acting—there is something identifiable that lets you know who the artist is.

This kind of distinctive voice is the apex of creativity. Finding your voice takes courage because it requires considerable self-awareness and honesty, and it takes time to hone it. But if you have the determination, you'll discover your own voice and nurture it in your photography. To get started, consider the following different approaches that you can bring to your nature photography in every season.

Documentation. This method emphasizes the reality and clarity of your subject. Say to yourself, "I want to show, as accurately as I can, exactly what this tree/landscape/flower looks like." Knowing that this is your goal will guide you in your decisions about lenses, film, aperture setting, and so on. It will also help you evaluate your photographic results.

Conveying Mood. Another approach attempts to express a mood or feeling. Maybe your subject makes you feel a certain way, or you're thinking about conveying a mood through your image. This way of planning your photograph differs a great deal from documentation. Here, you wouldn't necessarily be striving for clarity and accuracy. In fact, you might manipulate the image by softening the edges or exaggerating certain qualities of light, all to enhance the mood, which is your goal.

Aesthetics. For this approach, your main point is to extract beauty and grace from any subject, especially those imperfect specimens that have

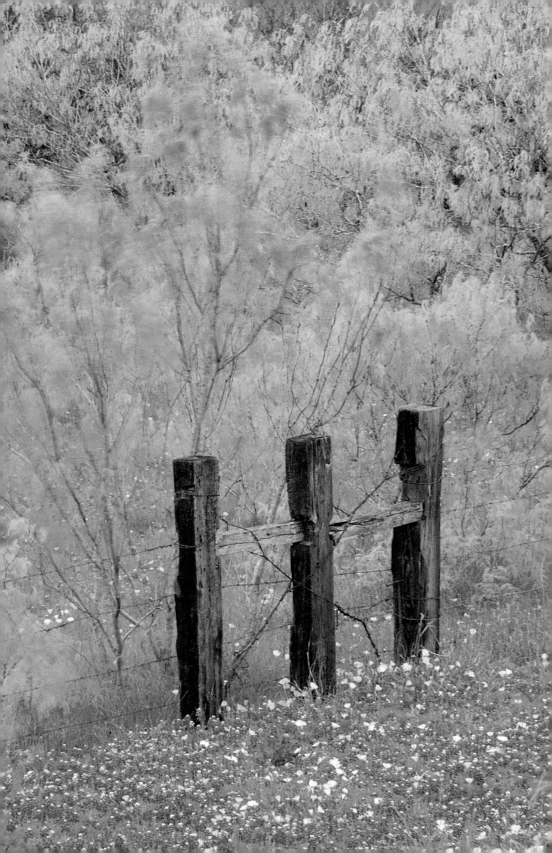

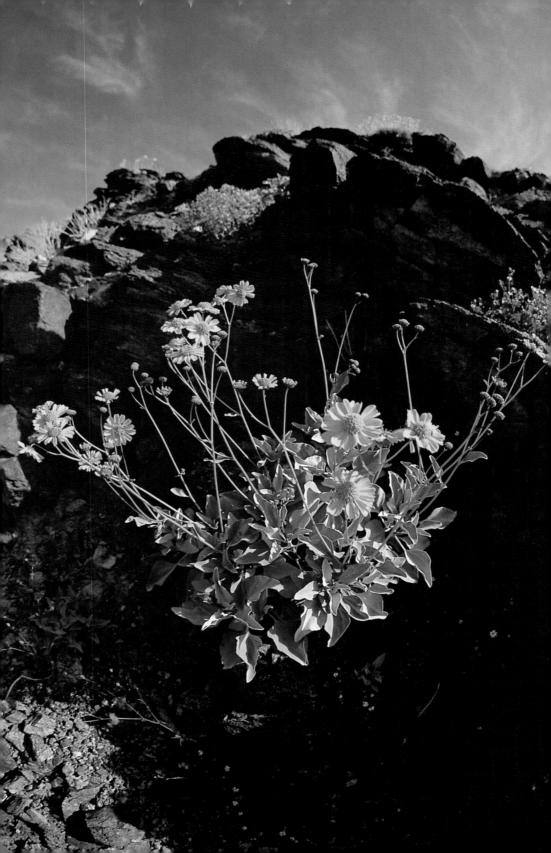

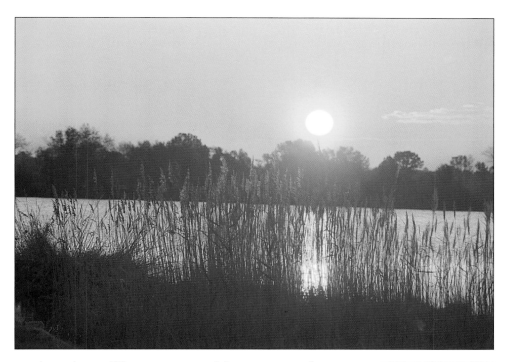

no inherent beauty. What counts is your ability to recognize the potential for beauty everywhere. The key word here is "potential." Think of any mundane object—peppers, eggs, weeds, or brambly undergrowth—and some photographer will have already successfully revealed its beauty.

Photographers like Edward Weston, Josef Sudek, Harry Callahan, and Eliot Porter brought an openness and utter commitment to their vision and its realization. This is what gives their images such undeniable power. Aiming for an aesthetic purpose is no easy task, but if you can see it in your mind's eye, you can do it.

These three purposes—and you may think of others—aren't mutually exclusive. As an exercise, try taking a single subject, such as your garden, house, or street, and creating images that reflect different purposes. Otherwise, as you shoot various nature subjects throughout the year, take a few moments to define your purpose so you can tailor the image to the specifics at hand.

CONVEY THE SPIRIT OF THE SEASON

Whatever your purpose, you'll also want to convey the spirit of each season. Poets and composers have long found emotional and psychological corollaries to each season. This isn't to suggest that each season has one well-defined, objective, and measurable spirit. But surely each season sparks a mood or energy, and people develop a particular spiritual connection to it.

Psychologists confirm the seasonal impact on people's feelings, whether these shifts are the result of associations or physiology, such as variations in the amount of daylight. Perhaps you gain a youthful vitality during the spring and experience a wistful nostalgia when autumn arrives. You might feel more melancholy in winter than in summer, or you might find new vigor in the bracing chill of winter compared to the languorous heat of summer.

I needed a warming filter to create a soothing mood in this sunset silhouette taken in Maryland. Shooting handheld, I used a Zuiko 35-70mm lens set at 40mm and exposed Ektachrome 100 S for 1/60 sec. at f/5.6.

I chose a wide-angle lens to document this coreopsis in its Anza Borrego State Park desert setting in southern California. Working with a Zuiko 18mm lens, I exposed Fujichrome Velvia at f/11 for 1/30 sec.

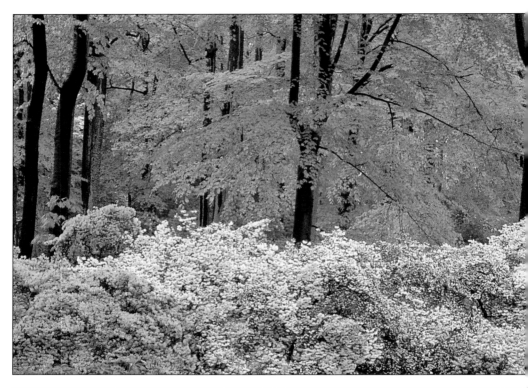

. By juxtaposing the massive azalea shrubs against the lively green foliage of the woods at Winterthur Garden in Wilmington, Delaware, I was able to convey a sense of spring renewal. With a Nikkor 80-200mm lens set at 100mm, I exposed at f/8 for 1/8 sec. on Fujichrome 100.

Tight framing with a powerful telephoto lens compressed the wildflowers in this Death Valley, California, mountain meadow, showing that summer is in full bloom. Working with a Zuiko 500mm mirror lens, I exposed for 1/60 sec. at f/8 on Fujichrome 100.

An overhead perspective combined the autumn forest with its reflection, thereby doubling the impact of the colorful foliage, a sure sign of the season. Shooting at Kentucky's Bernheim Arboretum, I used a Nikkor 80-20mm lens set at 100mm and exposed Ektachrome EPN at f/8 for 1/30 sec.

This monochromatic landscape of Wyoming's Grand Teton National Park conveys a sense of winter's stark and dramatic beauty. Working with a Zuiko 35-70mm lens set at 35mm, I exposed Fujichrome Velvia for 1/60 sec. at f/16.

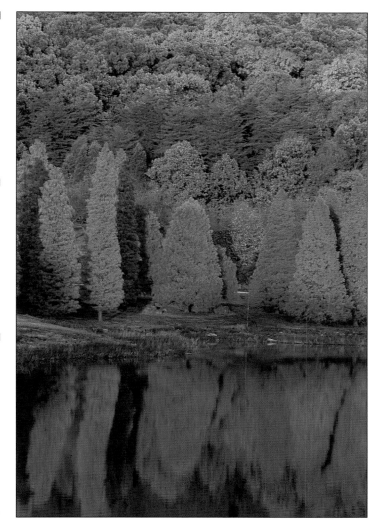

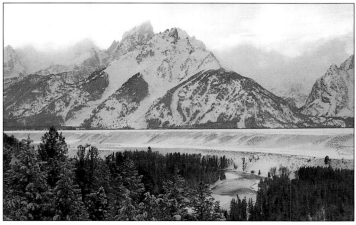

I deliberately used a telephoto lens plus a 14mm extension tube to focus on an Indian paintbrush and let other parts of this summer field of wildflowers become blurred to create this Impressionistic image. Shooting in Crested Butte, Colorado, with a Zuiko 180mm lens, I exposed for 1/250 sec. at f/4 on Fujichrome 100.

Venturing out to photograph in inclement weather and overcast light enables you to explore unexpected situations, such as this winter scene at Wave Hill in the Bronx, New York. Shooting handheld with a Zuiko 35mm lens, I exposed for 1/60 sec. at f/5.6 on Fujichrome 100.

The idea is to become aware of whatever feelings surface as a result of your seasonal reactions, and to use such self-reflection to inspire, shape, and refine your photographs. For example, you might express this dimension by saying, "I want to convey the spirit of romance I associate with spring," or "On this gloomy autumn day, I feel as if the earth is dying, and the raindrops are its tears." If you explore nature in each season with a fuller consciousness of its spirit, you'll undoubtedly enrich your photographs and express your deepest creative impulses.

DEVELOP AN AESTHETIC

No two people are exactly alike, even if they are photographers. Every time our workshop participants review the shots they've taken, they're amazed to see how different their images are even though they were working with the same visual raw materials. That individuality is part of each photographer's aesthetic.

To develop an aesthetic, you must know something about what makes you unique—what appeals to you and moves you. As a nature photographer, you'll find that it comes down to defining, as clearly as you can, the kinds of subjects you're drawn to and the kind of images you would most love to create. Are they dreamy or sharp-edged? Free and breezy or highly structured? Filled with bright colors or muted ones? Landscapes or microscopic closeups? These are the kinds of questions you might want to ask yourself. The answers will help you work on your own vision and resist the temptation to mimic what other photographers have done.

Keep in mind, too, that finding a photographic mentor—perhaps a friend who is an experienced photographer, a photography instructor, or a professional photographer whose work you admire—is helpful. This individual should be someone who shares your basic vision and can help you develop the skills you need to transform your vision into real images. But once you've mastered the techniques, let go of your guide, and see what new ways you can find to express your own creative powers.

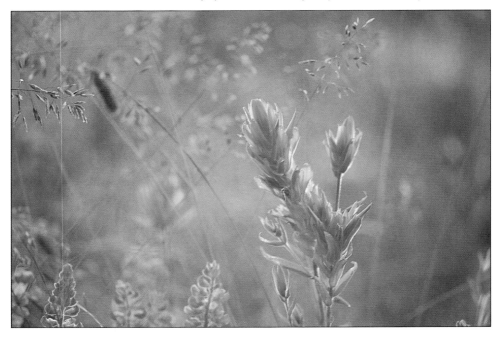

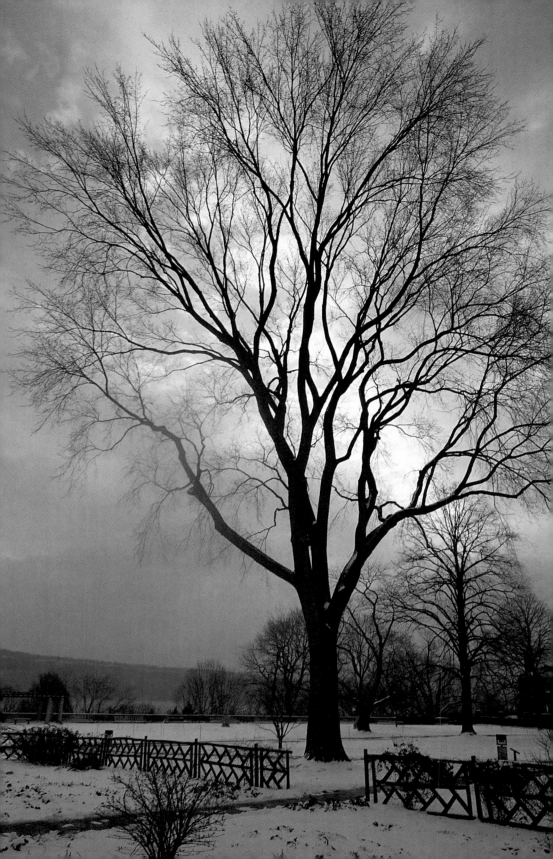

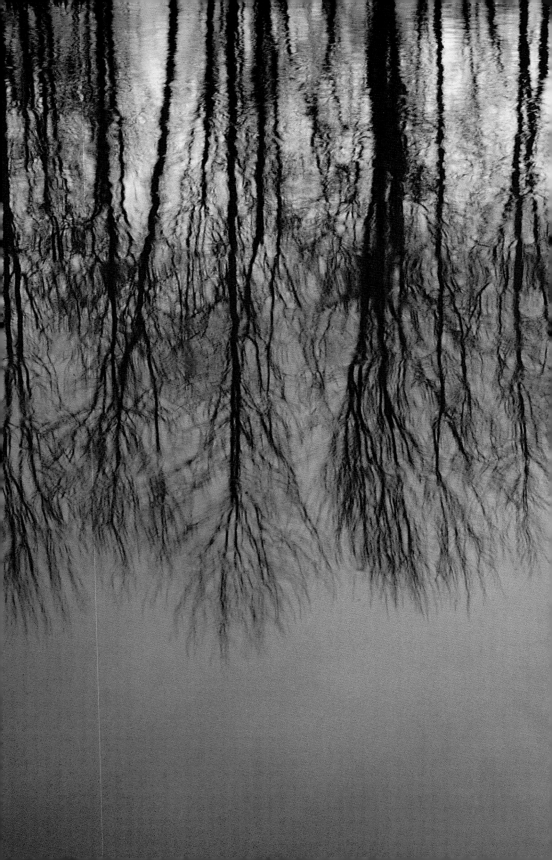

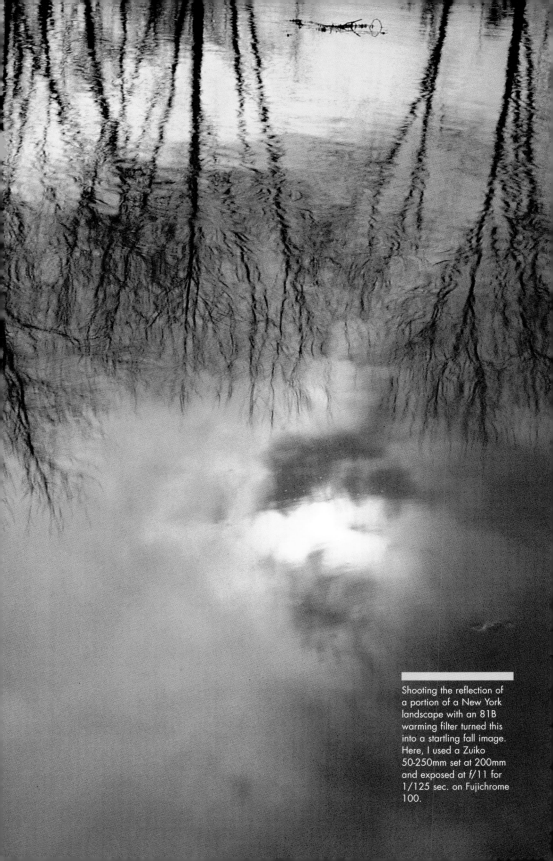

Shooting the reflection of a portion of a New York landscape with an 81B warming filter turned this into a startling fall image. Here, I used a Zuiko 50-250mm set at 200mm and exposed at f/11 for 1/125 sec. on Fujichrome 100.

Returning often to a favorite haunt encourages you to try unusual perspectives, like this truncated view of flowering crabapple trees in the spring. Working at the New York Botanical Garden, I used a Zuiko 50-250mm lens set at 120mm and exposed for 1/125 sec. at f/5.6 on Kodachrome 25.

During a fall outing to the New York Botanical Garden, the Bronx River glowed with the reflection of vibrant backlit foliage. With a Zuiko 50-250mm lens set at 150mm, I exposed Kodachrome 64 for 1/125 sec. at f/11.

A high perspective from a bridge over the Bronx River yielded this frosty winter overview of the New York Botanical Garden. Shooting with a Zuiko 50-250mm lens set at 100mm, I exposed at f/11 for 1/125 sec. on Fujichrome 50.

REVISIT THE SCENE

One way to discover more of your own vision—as well as one of the best ways to expand your creativity and explore the riches of each season—is to return to the same locations again and again and rephotograph them. The better you know the terrain, the more likely you are to spot interesting changes, even within a few days or weeks of each other.

Revisiting the scene lets you focus on the permutations from season to season, throughout one season, at different times of day, under a variety of lighting conditions, and in all sorts of weather. If the scene is largely unchanged, push the limits of your imagination by finding new perspectives or bringing out subtle shifts in color and mood.

If you're having trouble doing this, try keeping a journal, taking notes on your observations each time. Look back to some prior entry and see how this day is different. Then try to communicate that difference, even if it is just a matter of making better use of the light or working on the color. If it turns out that you have little or nothing to add, simply relax and enjoy your surroundings. You've come a long way down the road to rediscovering the seasons.

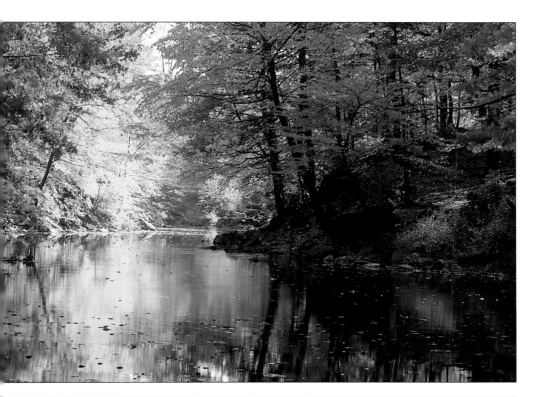

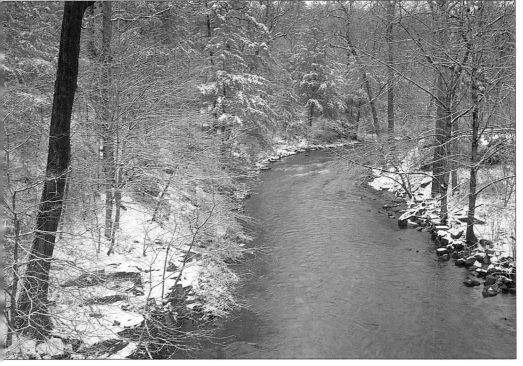

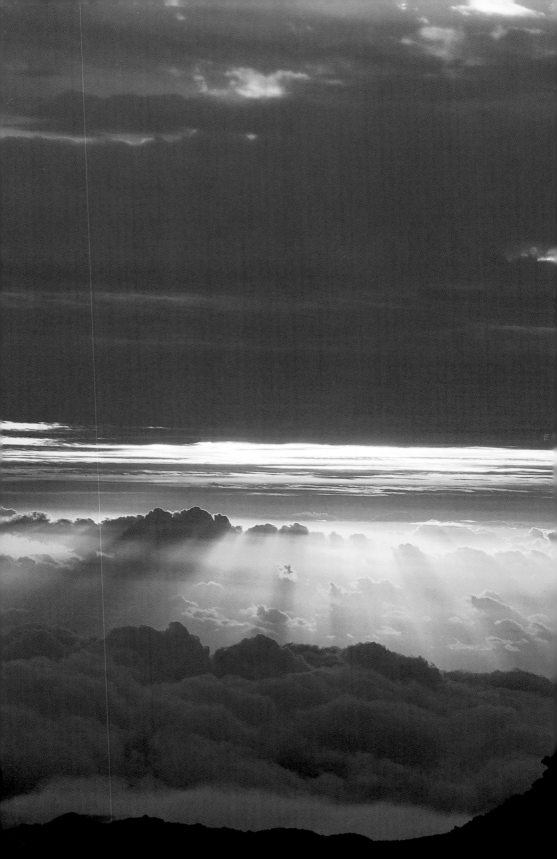

Tool Up

A lens with telephoto capacity can zoom in on distant subjects, such as these clouds during a winter sunset in Hawaii. Here, I used a Zuiko 50-250mm lens set at 250mm and exposed for 1/125 sec. at f/5.6 on Fujichrome Velvia.

Using a camera with a spot meter enabled me to expose for the delicate summer highlights at the water's edge at Acadia National Park in Bar Harbor, Maine. Working with an Olympus OM-4T and a Zuiko 50-250mm lens set at 150mm, I exposed Ektachrome 100 SW at f/11 for 1/8 sec.

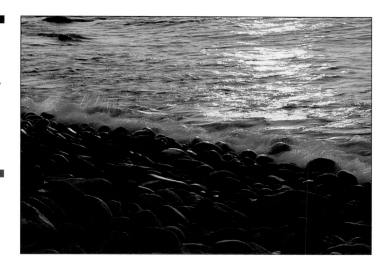

T his book begins with a discussion of vision rather than equipment and technique because we firmly believe that the kind of image you want to create should drive your choice and use of camera gear. We've seen too many photographers with the best equipment but with too little sense of inner vision. However, there is no question that you'll need to master your equipment and make it serve your needs by refining the skill with which you use it.

To blur the background behind this spring magnolia blossom at the New York Botanical Garden, I limited the depth of field via a macro lens and a 25mm extension tube. Here, I used a Nikkor 200mm macro lens at f/5.6, its widest aperture, and exposed Fujichrome 100 for 1/250 sec.

This chapter reviews the kind of equipment that nature photographers turn to most often. But don't make the mistake of rushing out with this as a shopping list. Unless you don't have any equipment at all or don't have the kind that will enable you to take quality nature photographs, you should start off by improving your skills with the gear you already own.

Of course, you can't do without some essentials. For example, if you don't already have a quality tripod, by all means go out and buy one. It will last many years and will give you an important advantage in all your nature shots.

The process of honing your skills will teach you what you can and can't do with the equipment you have on hand. Then you can build your collection slowly and deliberately, adding items that fill important gaps and help you expand your creative repertoire.

EXPAND YOUR TECHNICAL REPERTOIRE

The fear of equipment is the most daunting challenge facing most newcomers to serious nature photography. How, they wonder, will they ever know which lens to select or which setting to choose? There are so many numbers, so many features, so many options! Why, they often ask, can't we just put the camera on automatic?

The answer, of course, is that you can. But opting for convenience and ease isn't the way to create the special images most serious photographers want. There is no escaping the need for thoughtful analysis and care. To take some of the fear and confusion out of photography, you'll want to learn how to control the following basic variables.

Get an accurate meter reading. Accurate metering is the first step toward achieving the best possible exposure. Ideally, your equipment should let you opt for either a general or a narrow meter reading so you can isolate specific areas within the frame, with either the camera's built-in metering system, a spot meter, or a telephoto lens.

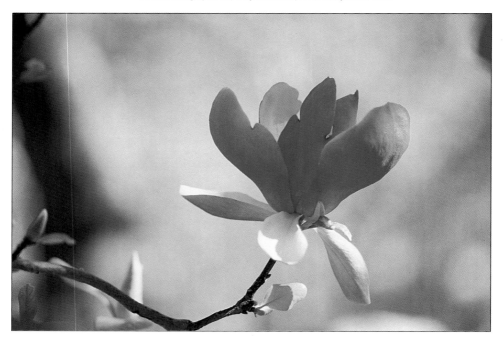

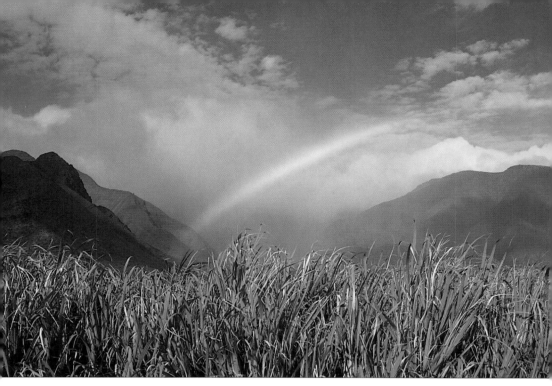

Several types of metering systems exist. With matrix metering, the meter measures the light in several segments of the viewfinder and averages them. With center-weighted metering, the meter reading is concentrated on but not limited to the middle of the frame. With spot metering, the light is measured in a very narrow range of about 1 to 3 degrees within the frame. Matrix metering and center-weighted metering are considered general forms of metering because they take into account what is in the entire frame. Spot metering is regarded as a narrow form of metering because it measures a precise spot within the frame. Spot meters enable you to isolate a small area that you want to expose properly. Having both types of metering available is a good idea.

Some cameras have a semiautomatic mode that responds to the camera's meter reading with "aperture priority" or "shutter-speed priority." When you set either the aperture or shutter speed (see below), these cameras automatically set the other, based on the meter reading. Depending on the nature of the shot and on the shooting conditions, you'll set one or the other. For example, if you're photographing on a calm day and want maximum depth of field, select the aperture-priority mode, and then let the camera choose the shutter speed. However, if you're shooting on a windy day and you're more concerned with stopping movement than with overall sharpness, you'll want to select the shutter-speed-priority mode and let the camera choose the aperture.

If you have a camera with a semiautomatic mode, check that it has a lock-in feature so you can meter a specific part of the frame and then recompose without losing that setting. If your camera doesn't have this feature, take a spot-meter reading of the most important element in the frame, set your aperture and shutter speed accordingly, and then frame your shot. (We prefer cameras with manual controls or manual-override features; the lock-in feature is an extra but isn't essential for enabling you to pinpoint the meter reading on a subject that might not be at the center of the frame.)

A careful meter reading on the deep blue of the sky, plus polarization, brought out the colors of this autumn rainbow in Maui, Hawaii. Shooting hand-held with a Zuiko 28mm lens, I exposed for 1/125 sec. at f/11 on Fujichrome 100.

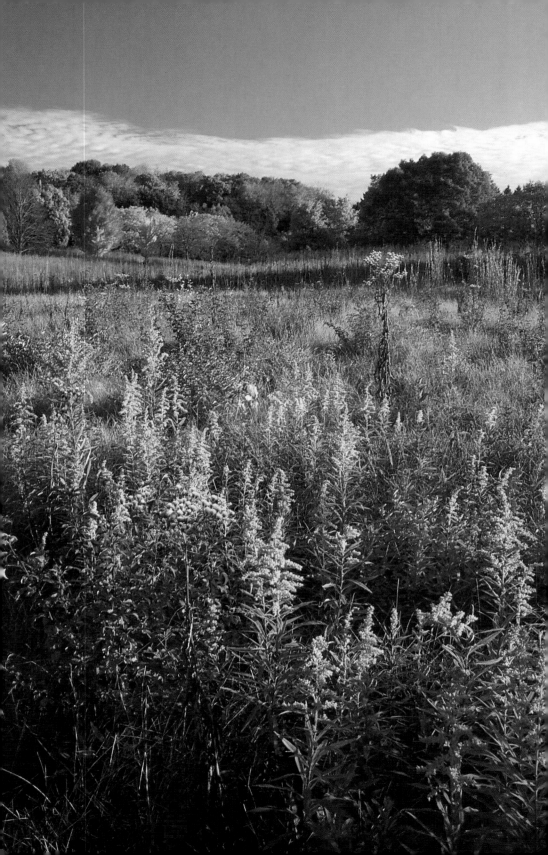

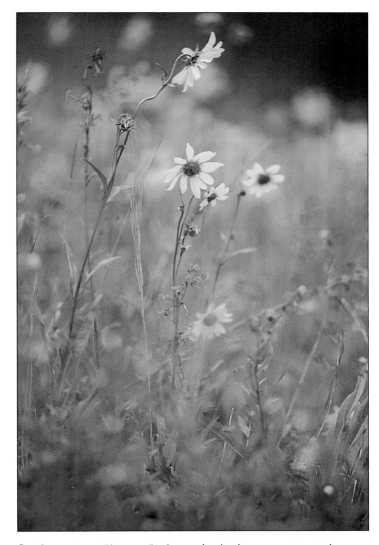

A small aperture setting produced good depth of field for this sharp autumn landscape in Ohio. With a Zuiko 24mm lens, I exposed Ektachrome 100 SW for 1/60 sec. at f/16.

A powerful telephoto lens at its widest aperture setting limited the depth of field for this slice-of-the-scene shot of a summer meadow filled with sunflowers. Shooting in Crested Butte, Colorado, with a Zuiko 300mm lens and a 25mm extension tube, I exposed for 1/250 sec. at f/5.6 on Ektachrome 100 SW.

Set the aperture. "Aperture" refers to the diaphragm opening at the moment when the shutter is released. The aperture is calibrated in f-stops. These are the settings on the aperture-control ring that show how much the aperture will close down. The higher the f-stop number, the more the diaphragm closes down at exposure. The smallest-numbered aperture setting, such as $f/3.5$, closes the least. The largest number, such as $f/22$, closes the most. So an aperture of $f/16$, for example, closes more than $f/5.6$.

When you look through the lens, you're viewing the scene at its brightest, i.e., the aperture is wide open. Each higher f-stop cuts light intake in half from the preceding setting provided you keep the shutter speed constant. The aperture setting, together with the shutter speed, controls the amount of light entering the lens. To keep light intake constant, you can use a combination of f-stops and shutter speeds that will result in the same exposure. For example, shooting at $f/22$ for 1/30 sec. is identical to shooting at $f/16$ for 1/60 sec. or $f/11$ at 1/125 sec.

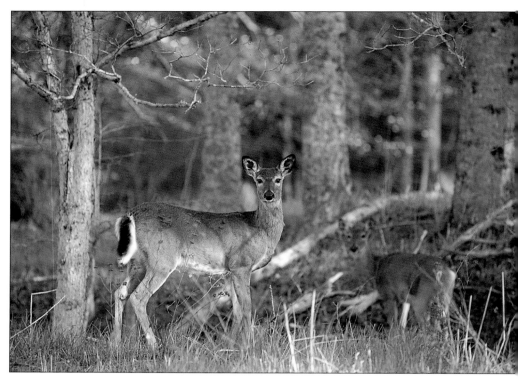

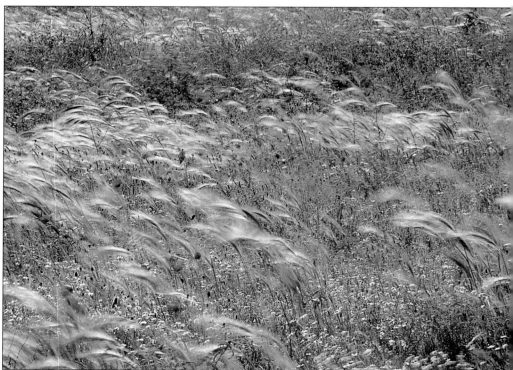

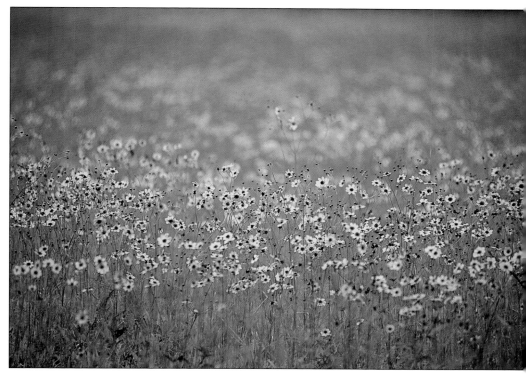

More important for aesthetic control, however, the aperture determines depth of field (see below).

Set the shutter speed. The "shutter speed" refers to the amount of time the shutter remains open during exposure, which is expressed as fractions of a second. However, only the denominator appears on the control ring. For example, a shutter speed of 60 means an exposure of 1/60 sec. This setting helps control light intake and also is the determining factor in the control of movement. Fast shutter speeds, such as 1/500 sec., help freeze movement when you want maximum sharpness. Slow shutter speeds, such as 1/15 sec., record movement, something you might want for shooting flowing water or swaying grasses, depending on your aesthetic vision.

Control depth of field. "Depth of field" refers to the range of sharpness that exists in front of and behind your focal point. It varies according to several factors, all of which you should be able to control to some extent either to maximize sharpness throughout your image or to selectively throw some parts of your image out of focus. Depth of field becomes shallower as you get closer to your subject, use a longer lens, or use a wider aperture setting. Conversely, depth of field is greatest as you move away from your subject, use a wider-angle lens, or choose a narrower aperture setting.

Control the focus. Camera lenses rotate to bring the image into sharp focus. Distant subjects are easier to focus on than closer ones, and focusing is easiest in bright sunlight. For general scenics and overviews, you'll probably focus at infinity. For vignettes, which are middle-range images

Precise focusing on the foreground flowers and a long telephoto lens created a mix of sharpness and blur in this spring meadow in Mississippi. Here, I used a Zuiko 50-250mm lens set at 250mm and exposed at f/5.6 for 1/250 sec. on Fujichrome Provia.

A camera with automatic exposure enabled me to capture the sudden appearance of these deer Tennessee's Great Smoky Mountains National Park. With a Zuiko 180mm lens, I exposed Ektachrome 100 SW at f/2.8 for 1/125 sec.

A fast shutter speed caught swaying grasses at their point of greatest curvature in this spring bloom in Israel. Working with a Nikkor 200mm lens, I exposed for 1/500 sec. at f/5.6.

For floral closeups, I focus on the plants' interior structures, as I did for this shot of summer columbine in Colorado. Working with a Zuiko 90mm lens and a 25mm extension tube, I exposed Ektachrome 100 SW for 1/15 sec. at f/22.

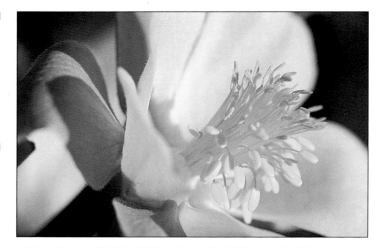

A slow shutter speed captured the flow of water in this autumn waterfall, turning it milky white. Shooting in Hawaii, I exposed at f/11 for 1/15 sec. on Ektachrome 100 SW.

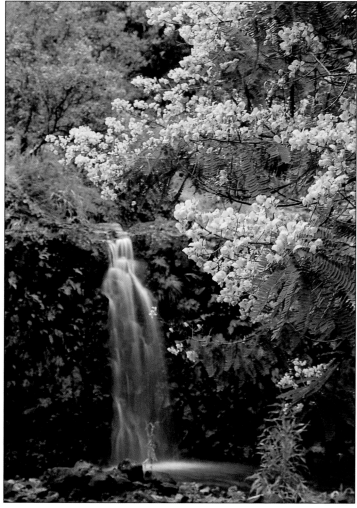

that home in on an aspect of the larger scene, or for wide-angle shots, focus on the point that is about one-third up from the bottom of your frame. For closeups, you should focus on the feature that is most important to keep sharp, such as the central structures of a flower or the eye of a bird.

USING YOUR EQUIPMENT EFFECTIVELY
Think of your camera equipment as your tool kit. As you become familiar with each tool and what it can do, you'll feel more comfortable using it. By the way, don't let other photographers who have a full tool kit with the finest equipment money can buy intimidate you. They're often as bewildered as those who are just starting out, although they might not want to admit it. The proof, of course, lies in how consistently they can produce outstanding images.

Working with a new tool seems slow and uncertain. The results might be disappointing—and perhaps not as good as those you used to take with your point-and-shoot (P&S) camera. Don't let that throw you off.

I selected a medium-wide-angle lens to home in on a low branch of sugar maples in New York; I wanted to feature the bright orange fall foliage while incorporating the trunks of the stand of trees. With a Zuiko 35mm lens, I exposed for 1/60 sec. at f/11 on Fujichrome 100.

A polarizing filter turned the water of the pond jet black for a dramatic backdrop for this autumn waterlily. Shooting at the Chicago Botanic Garden, I used a Zuiko 50-250mm lens set at 250mm and exposed at f/5.6 for 1/30 sec. on Ektachrome 100 SW.

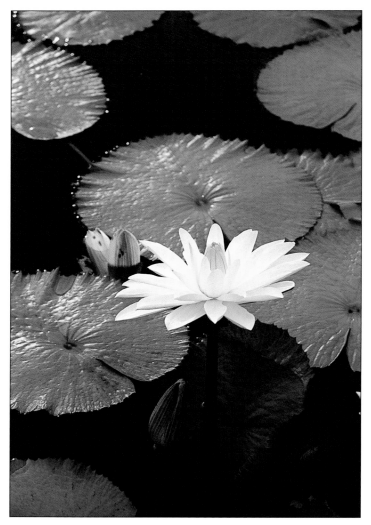

Just continue to learn from what doesn't work so that you don't repeat the same mistakes down the line.

A good way to discover the limits of any piece of equipment is to keep careful notes. In advance, prepare a notebook with a page numbered for each shot on your roll. At the top, indicate the date, film type, weather and lighting conditions, location, and general purpose of the shoot: for example, improving color rendition, experimenting with depth of field, or using various shutter speed settings on water. Then, for each shot, indicate the lens, any filter, and the exact camera settings for aperture and shutter speed.

Whenever you test a new item or technique, change only one variable at a time. When the film comes back, compare the results with your notes to see which combination worked best. When you have more experience, try to predict the photographic outcome for each shot. Write that in your notebook as well, then see how good your predictions were. Over time, you'll find that you've expanded your technical repertoire considerably and lost your fear of gear.

CAMERA BASICS

Today's cameras are computerized wonders. They offer every kind of automatic feature, from automatic exposure to autofocus. Nevertheless, professionals still swear by manual cameras, which are increasingly hard to come by. The simpler the camera, the easier it is to understand and the less expensive it is to maintain.

But automatic cameras are today's norm. They are beneficial for general photography, especially when you have to react quickly to movement or changes in light conditions. However, for nature photography, you usually have time to fine-tune camera settings for the advantages they afford. If you have an automatic camera—and certainly if you're considering buying one—make sure it has manual override capacity so you can determine the best settings for yourself. Consider the following cameras for year-round nature photography.

35mm SLR Cameras. These small, popular cameras are noted for their lightness and flexibility, and today 35mm SLR models offer the latest in electronic sophistication. You view the subject through the lens so the composition you see is what you get (as opposed to rangefinder cameras or P&S cameras, where you look through a viewfinder that approximates the final image). Though the film image is small, improvements in film quality have enabled enlargements to be super-sharp, even for 20 x 30-inch blowups.

Medium-Format Cameras. These cameras use larger film sizes; squares of 6 x 6cm, 6 x 7cm or 4.5 x 6cm are the most common. Some nature photographers who are serious about printing most of their images (or for a few very demanding publications) consider these film sizes to be an advantage because the resulting images can be sharper and contain more detail. But compared to 35mm SLRs, medium-format cameras are larger,

A point-and-shoot camera was ideal for this quick roadside shot of summer daisies taken in uniform light. Shooting in Crested Butte, Colorado, I used an Olympus Stylus 115 and Ektachrome 100 SW.

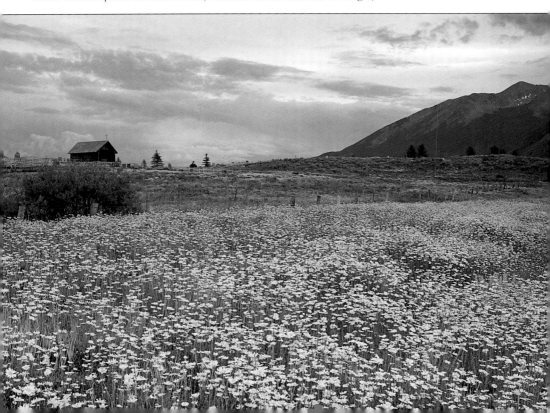

A camera with a built-in light meter made determining exposure simple for this photograph of an autumn meadow at Ohio's Holden Arboretum. With a Zuiko 35mm lens, I exposed for 1/30 sec. at f/11 on Ektachrome 100 SW.

A close-focusing, wide-angle lens blew up the foreground poppies and at the same time included the receding spring landscape. Shooting in Israel with a Nikkor 24mm lens, I exposed Kodachrome 25 for 1/60 sec. at f/16.

A wide-angle setting encompassed this winter overview taken at Canyonlands National Park, Utah. Here, I used a Zuiko 35-70mm lens set at 35mm and exposed for 1/15 sec. at f/8 on Ektachrome 100 SW.

heavier, and more difficult to use when quick responses are important, and they lack some of the newest technological wizardry.

Point-and-Shoot Cameras. Small, light, easy to use, and completely automatic and foolproof, it is no wonder that these cameras have been nicknamed "PhD cameras" for "push here, dummy." P&S can be counted on for a decent rather than outstanding image. Many now contain electronically sophisticated systems for metering, focusing, exposure control, and electronic flash. They often include built-in zoom lenses for more composition options. For example, the Olympus Stylus Zoom 115 has a zoom range of 3:1, which means that the image on the film is three times as large at full zoom as it would be at no zoom.

However, lens quality is good, and all the electronic programs are geared toward an acceptable average. Since these cameras have little or no override capability, use them primarily when you plan to walk far afield and want to carry only an especially light piece of equipment. New additions to this category are Kodak's Advanced Photo System (APS)

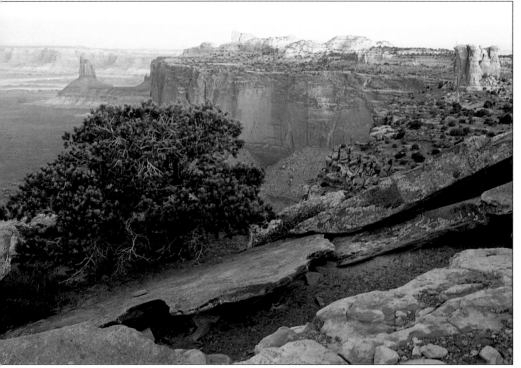

This ultrawide-angle perspective made the foreground dune ripples very prominent while showing the setting in Monument Valley, Arizona. A polarizing filter enriched the warm fall colors. With a Zuiko 18mm lens, I exposed at f/22 for 1/8 sec. on Fujichrome Velvia.

For this late winter composition, I used a wide-angle setting to feature the receding shoreline at Point Reyes National Seashore, California. Working with a Zuiko 35-70mm zoom lens set at 35mm, I exposed for 1/250 sec. at f/8 on Ektachrome EPN.

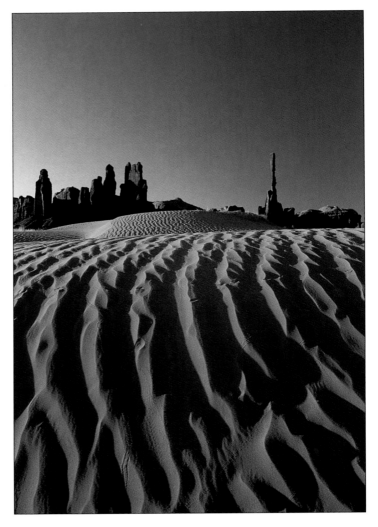

cameras, which use small 24mm film cartridges and can be programmed for standard, wide-angle, and panoramic formats. The cameras' small size and flexible formats are a boon when you're traveling. But the small film reduces sharpness, which can be problematic when you want to enlarge images.

LENSES

Thankfully, the days when photographers had to lug a load of lenses are gone. Today, you can get the composition versatility you want with several zoom lenses. Since the quality of zoom lenses has improved, they've become the reliable workhorses for much nature photography. You can meet almost all your photographic needs with a few well-chosen lenses.

20-35mm Zoom Lens. This lens takes care of most wide-angle shots, letting you move reasonably close to a foreground subject and still include the vast expanse of the background. Most wide-angle zoom lenses focus as close as 4 to 5 feet from the subject. Lenses that focus

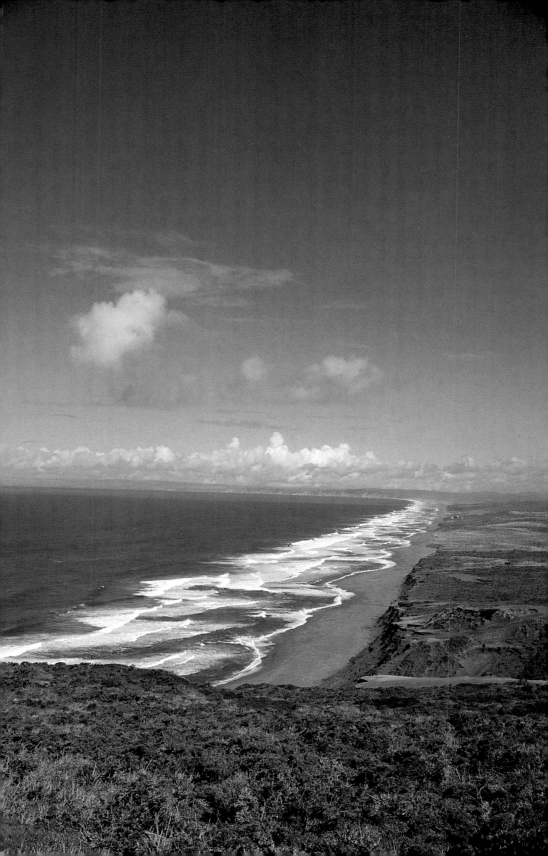

A telephoto setting separated these summer sunflowers in Colorado from their shadowy background. With a Nikkor 80-200mm lens set at 150mm, I exposed for 1/500 sec. at f/4 on Ektachrome 100 SW.

To create an abstract composition, I compressed the bands of spring color in the French countryside via a telephoto setting. Here, I used a Zuiko 50-250mm lens set at 250mm and exposed at f/16 for 1/30 sec. on Fujichrome 100.

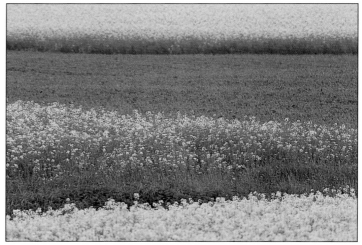

closer are more expensive but let you create more interesting and diverse compositions. Anything wider than 24mm will distort the image in ways that some photographers find disorienting but others consider an interesting special effect. Here, the lens exaggerates the foreground in relation to the surroundings and bends vertical lines inward at the top. If you already own an ultrawide-angle lens, go ahead and use it if you like the effect. Don't buy one, however, unless you know it will let you do something you can't already do with a 20-35mm lens.

35-80mm Zoom Lens. This is likely to be the lens you'll use most often because it renders a scene very much as your eye sees it, while giving you some maneuverability. Get the fastest possible lens you can afford, one that opens to an aperture of f/2.8 or larger so you can shoot in dim light.

80-200mm Zoom Lens. This lens lets you magnify distant subjects, enlarging them well beyond what the unaided eye would see. It also telescopes and isolates parts of a vista by compressing space to create an interesting "slice of the scene" effect (see page 124).

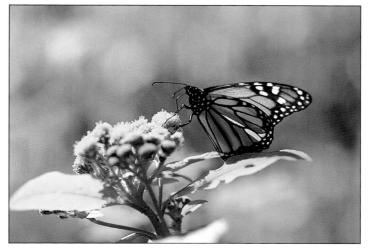

Using a macro lens permitted me to photograph this monarch butterfly in Mexico one summer with adequate magnification without having to get very close. Shooting handheld from a distance of 18 inches with a Nikkor 200mm macro lens, I exposed for 1/500 sec. at f/4 on Fujichrome 100.

For this shapely elm tree in an autumn mist in Kentucky, I shot with a telephoto lens from a distance of 200 feet. Here, I used a Zuiko 180mm lens and exposed Fujichrome Velvia for 1/8 sec. at f/4.

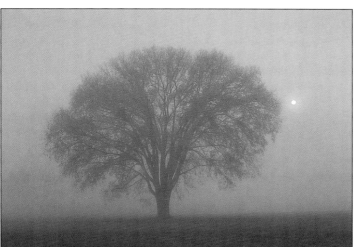

90-105mm Macro Lens. Macro lenses come in various focal lengths (they aren't zoom lenses), but all can focus very close to the subject. While a 50mm or 55mm macro lens is excellent for closeups of nature, a moderate-telephoto macro lens, such as a 90mm or 100mm macro lens, produces the same size image from slightly father away. This makes it more versatile in situations when you can't get close, such as when you're photographing butterflies, details of fall foliage, or flower closeups. Look for a macro lens that reproduces a life-size image on the film; this is referred to as a 1:1 ratio.

300mm Telephoto Lens. This high-power lens—or an even higher one—is optional, although it expands the advantages of a more moderate telephoto lens. However, it is a must if you're especially interested in photographing birds and wildlife because it magnifies creatures that generally aren't close enough to fill the frame. (See our companion volume, *The Field Guide to Photographing Birds*, for specific suggestions and detailed instruction on using high-power telephoto lenses.)

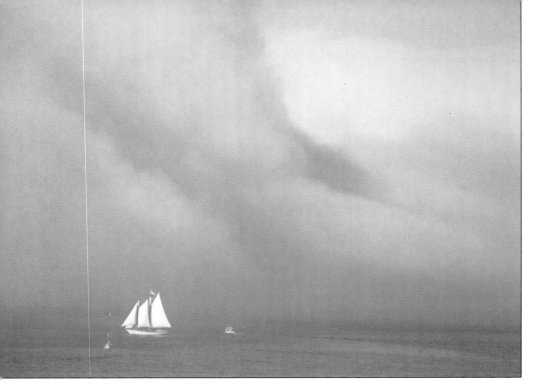

FILMS

The longest setting on a zoom lens pulled in the distant summer clouds for an effective backdrop for this white sailboat. Shooting handheld off the coast of Bar Harbor, Maine, I used a Zuiko 50-250mm zoom lens set at 250mm and exposed at f/8 for 1/250 sec. on Ektachrome 100 S.

To record the verdant greens in this Costa Rican mountain valley in December, I used Fujichrome Velvia. With a Zuiko 35-70mm lens set at 35mm, I exposed for 1/125 sec. at f/8.

Ektachrome 100 SW with a warming filter brightened the earth tones in this overview of Monument Valley, Arizona. Shooting with a Zuiko 35-70mm lens set at 35mm, I exposed at f/22 for 1/8 sec.

The market in films has both expanded and improved in recent years. Among the improvements are better color saturation, greater latitude in handling contrasty light, and finer grain for greater sharpness. Almost all brand-name manufacturers now produce excellent films and develop new types regularly. Despite the films' consistent quality, they still differ in important ways. This is precisely why professional photographers usually work with two or more camera bodies at a time, each loaded with a different film.

Check the films mentioned throughout this book to see if you prefer one particular film type or another. And stay up-to-date by reading about the film tests that reputable photography magazines, such as *Popular Photography*, perform. Unless you know in advance that you're going to face a particular situation, such as color or type of light, that certain films handle especially well, Ektachrome 100 SW is a good, all-purpose slide film that responds well to many different conditions and can be turned into prints as needed. Consider the following factors before you choose a film.

Tonality. Films can have a tonality, which is a faint color cast, that affects the way all colors reproduce. Warm-toned films, like Ektachrome 100 SW and Kodachrome 25 KM and 200 KL, give a flush tonality—a warm wash of color—to a scene, as if you're looking at the world with faintly tinted rose-colored glasses. Cool-toned films, such as Fujichrome Provia, Sensia, Velvia, and Astia, portray a scene with a faint bluish cast. Agfa 50 and 100 and Ektachrome 100 S are fairly neutral-toned films, which means that they don't exaggerate any particular colors and don't add their own color cast to an image.

Before you select a film, think about what colors you are likely to encounter in each season (see Chapter 4 for a full discussion of colors), as well as how a film's tonality will affect them. To leave the colors as

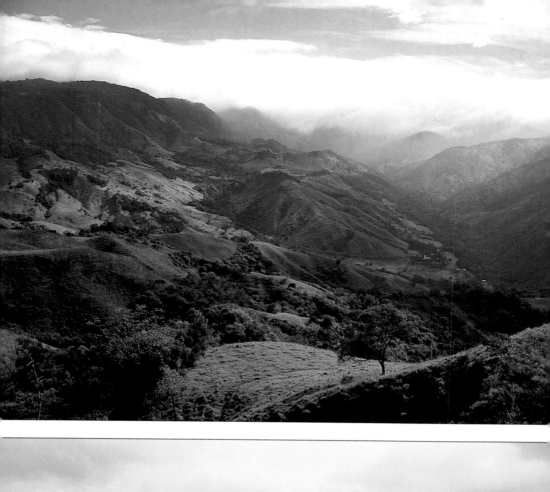

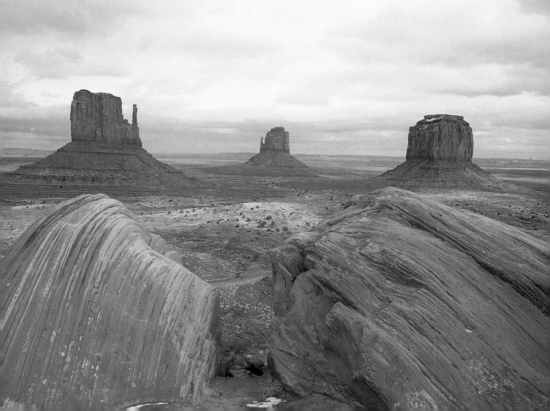

Fujichrome 64T, a film designed for tungsten lighting, turned the sky and water a cool blue for an offbeat, abstract rendering of California's Death Valley National Monument in spring. Working with a Zuiko 24mm lens, I exposed at f/16 for 1/15 sec.

Fujichrome 100 brought out the cool tones behind these autumn grasses in Steamboat Springs, Colorado, for interesting contrast. Here, I used a Zuiko 35-70mm lens set at 35mm and exposed for 1/60 sec. at f/8.

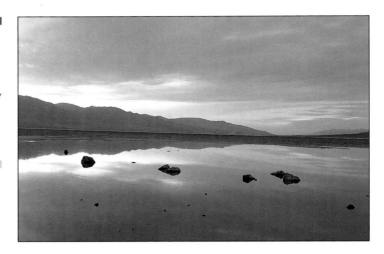

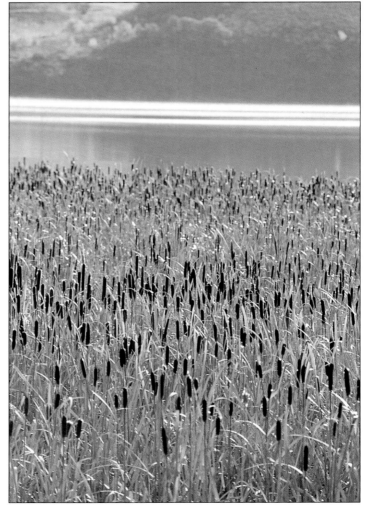

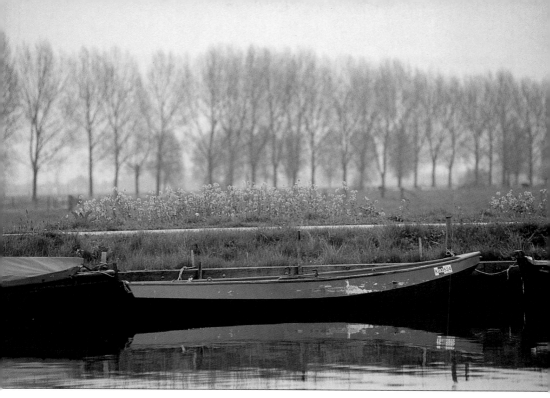

they are, use a neutral-toned film. To enhance or compensate for the existing hues, use a film with similar or contrasting tonalities. For example, a warm-toned film will enrich the colors of fall foliage or reduce the blue effect of the sky on snow.

Color Rendition. Even among films with similar tonalities, color rendition varies. For example, both Ektachrome 100 S and Fujichrome Provia are essentially cool-toned films, yet the Ektachrome has a magenta/purplish cast while the Provia is more bluish. Those differences become especially important in nature photographs in the color rendition of greens, but you should also check the variations in other colors.

Contrast. Films can increase or decrease the amount of contrast in an image. High-contrast films, which turn dark colors darker and whites whiter, include Fujichrome Velvia, Astia, and Provia. Low-contrast films, which turn extremes of dark and light colors toward the middle tones, include Ektachrome 100 SW and Kodachrome 25. Films like Ektachrome 100 S, Agfa 50, and Agfa 100 fall in between.

Choose films according to the contrast effect you need. Use a high-contrast film in low-contrast light to spike up colors that appear similar and grayish. Try a low-contrast film in bright sun to reduce the extremes of dark and light that could result in underexposure or overexposure, respectively, in important parts of the image.

You can learn whether a film is high- or low-contrast either by reading about films in photography publications or by conducting your own tests. To do a contrast test, buy several films; shoot them under various lighting conditions, being sure to keep careful records; and compare the results. Be aware, however, that doing such a test is cumbersome. Looking up films' contrast effects in a reputable photography magazine, such as *Popular Photography* or *Petersen's Photographic*, is much easier.

Fujichrome Velvia increased the contrast and enlivened the colors in this muted spring scene of a canal in Holland. Shooting with a Zuiko 35-70mm lens set at 40mm, I exposed for 1/15 sec. at f/11.

Ektachrome 100 SW added contrast to this December shot of a palm tree, thereby separating the fronds from the backdrop. Working in Costa Rica with a Zuiko 35-70mm lens set at 35mm, I exposed at f/11 for 1/30 sec.

Ektachrome EPN kept the greens and blues natural in this spring shot of the California coastline. Here, I used a Zuiko 35mm lens and exposed at f/11 for 1/125 sec.

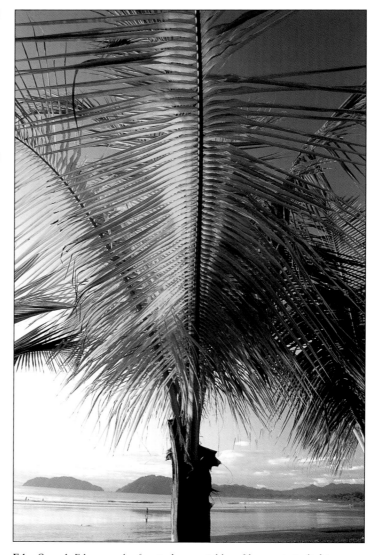

Film Speed. Film speed refers to how quickly a film reacts to light, calibrated according to ISO (International Standards Organization) numbers. The higher the number, the faster the film, and each doubling of the ISO number represents a doubling of the film speed. So films labeled ISO 200 react twice as fast as those marked ISO 100, films labeled ISO 100 react twice as fast as those marked ISO 50, and so on.

Fast films let you use a faster shutter speed or a smaller aperture in a given lighting situation. You might want to use fast film in dim light to stop movement with a fast shutter speed, especially if you want to use a small aperture. The tradeoff is that very fast films have larger grain. These are the particles of metallic salts that are in the film emulsion, and that cause an image to lose clarity. However, the newest films have improved so much that these factors are no longer as important as they once were. Fujichrome 400, for example, is an excellent fast film with quite acceptable sharpness.

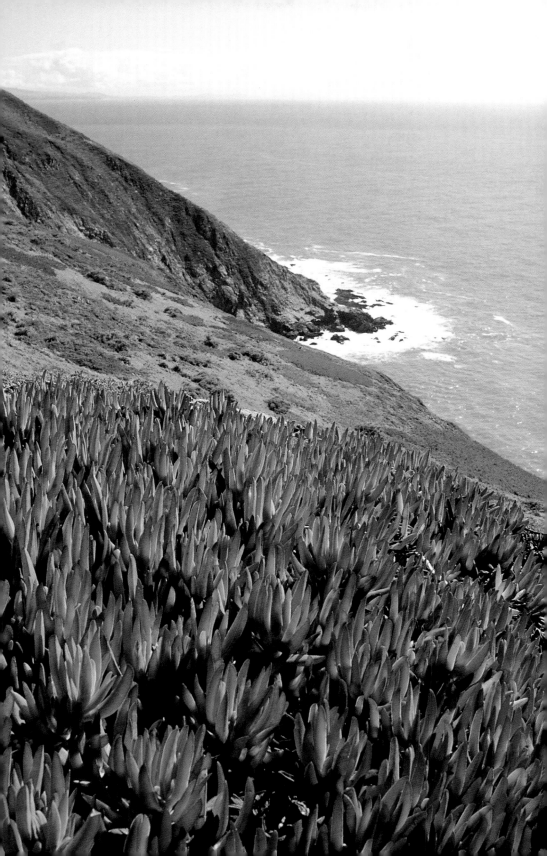

Fujichrome Velvia increased the contrast and punched up the reds in this floral closeup of Indian paintbrush, photographed in the spring. Shooting at Death Valley National Monument, California, with a Zuiko 90mm macro lens, I exposed for 1/8 sec. at f/11.

Ektachrome 100 SW was fast enough to let me use a small aperture in order to maximize sharpness in this fall sunrise landscape, shot in Canyonlands National Park. With a Zuiko 35-70mm lens set at 35mm, I exposed for 1/15 sec. at f/22.

I pushed Fujichrome 100 to ISO 200 to obtain the added speed needed to capture this fox trotting in Yellowstone National Park in Wyoming one winter. Shooting handheld with a Nikkor 80-200mm lens set at 200mm, I exposed for 1/30 sec. at f/2.8.

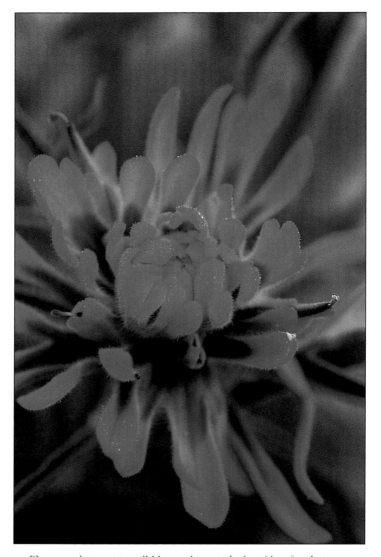

Photographic purists still like working with slow films for their very fine grain and beautifully saturated colors. As long as you're working with a tripod and aren't concerned about having to freeze movement, you can use a slow film. Try Fuji Velvia, Kodachrome 25, or Agfa 50.

If you realize you need faster film than you already have in your camera or than you have on hand, you can "push" the film to gain additional speed. Keep in mind that you'll have to process the entire roll at the "pushed" level. To "push" film, look for the film-speed dial, and set the manual override to double the actual film speed. For example, if you have ISO 50 film in your camera, set the dial to ISO 100. This will let you use a faster shutter speed or a smaller aperture setting. Pushing film also increases color contrast, a reason some photographers give for pushing film routinely. Most professional photographers use films around ISO 100 because they are of mid-range speed, have fine grain, and can be pushed easily to ISO 200. Of these, Ektachrome 100 SW is the film of choice.

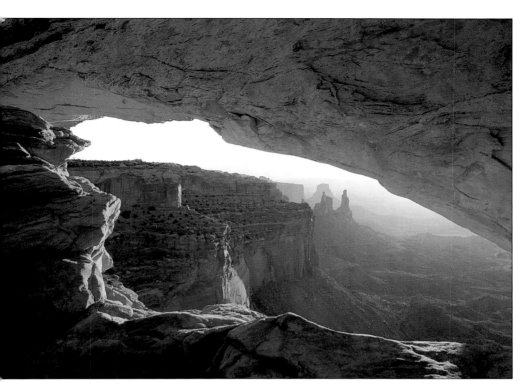

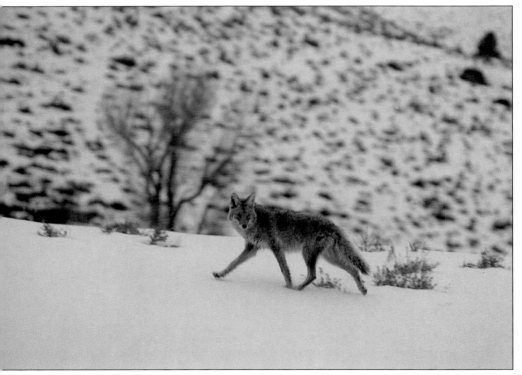

Fujichrome 100 was fast enough to permit me to photograph this otter in Maine's Acadia National Park the moment it turned its head. Here, I used a Zuiko 35-70mm lens set at 35mm and exposed for 1/60 sec. at f/5.6.

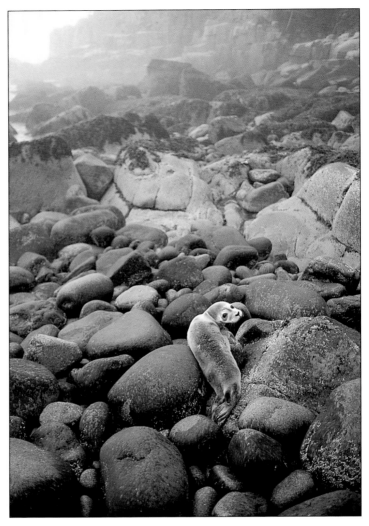

FILTERS

Filters, while not absolutely essential, are simple devices that can make the difference between ordinary and extraordinary nature images all year long. These glass devices, which screw onto the front of your lenses, can have a subtle or a dramatic impact on your images. Of the dozens of different filters on the market, the following few are close to indispensable.

Polarizing Filters. Polarizers help control glare and reflective highlights on foliage, water, and rocks, thereby deepening and brightening their colors. Polarizers come in neutral tone and warm tone. They have two interconnected rings. The inner ring screws onto the lens, and the outer ring rotates a full 360 degrees, thereby varying the degree of polarization as it turns.

You can see the exact degree of polarization, which is the refraction of incoming light, as you look through the lens and rotate the outer ring of the polarizer. With a neutral-tone polarizer, the sky might turn a deeper blue, water might become more transparent, and foliage might become

a richer green. Although some light is lost because the neutral-tone polarizer cuts down the amount of light entering the lens, it doesn't add color. The polarizing effect is most dramatic in bright light and at a right angle to the sunlight. Just be careful not to remove reflections you want to include in your image.

In addition to a neutral-tone polarizer, you might want a warm-tone polarizer to enhance the earth tones in landscapes. The downside: you'll lose some light—about 1 1/2 f-stops—but with bright light that shouldn't be a significant sacrifice. Polarizers aren't available for P&S cameras. Auto-focus SLRs require particular kinds of polarizers or they won't focus properly. For autofocus SLRs, be sure to ask for a "circular" polarizer. Always try the polarizer on the lens you plan to use to make sure it fits properly.

Graduated Neutral-Density Filters. This type of filter goes from dark at the top to clear at the bottom. A graduated neutral-density (ND) filter is a lifesaver when you're facing a colorless sky. On a bright overcast day, an expanse of white sky can kill even the loveliest landscape.

The extra speed of Fuji-chrome Provia made it possible for me to shoot this pea shrub on Baker Island, Maine, using a fast shutter speed. With a Zuiko 28mm lens, I exposed for 1/125 sec. at f/5.6.

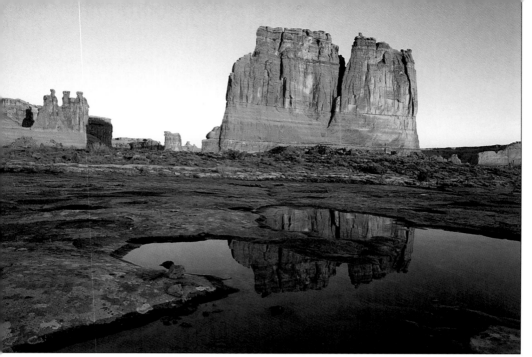

A polarizing filter helped to eliminate glare from the reflection and deepened the colors in this autumn landscape. Shooting in Utah's Arches National Park with a Zuiko 28mm lens, I exposed Ektachrome 100 SW at f/22 for 1/30 sec.

A warm-toned polarizing filter removed unwanted reflections, thereby enriching the colors of the fall foliage and deepening the blue of the sky. Working in Ohio with a Zuiko 35-70mm lens set at 35mm, I exposed at f/8 for 1/60 sec. on Fujichrome 100.

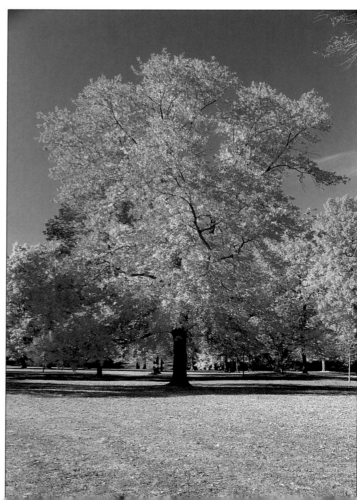

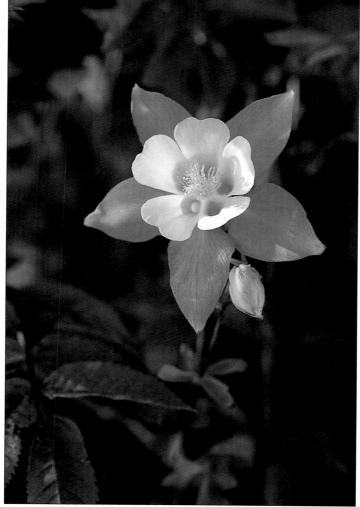

For this summer closeup of a Colorado columbine, I used a polarizing filter to eliminate glare from the background greenery. This intensified the contrast between the backdrop and the flower, setting it off dramatically. Shooting with a Zuiko 90mm macro lens, I exposed Ektachrome 100 SW at f/11 for 1/30 sec.

A polarizing filter helped control reflections on this pond in Maine's Acadia National Park, bringing the grasses into sharp relief. Here, I used a Zuiko 24mm lens and exposed for 1/60 sec. at f/11 on Fujichrome 100.

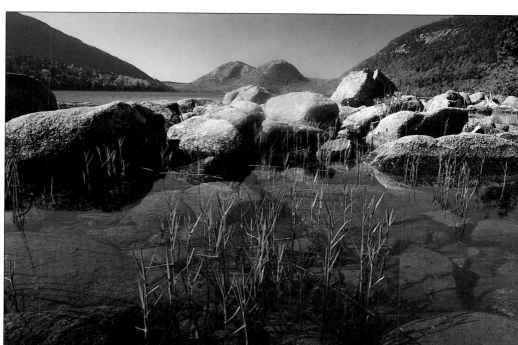

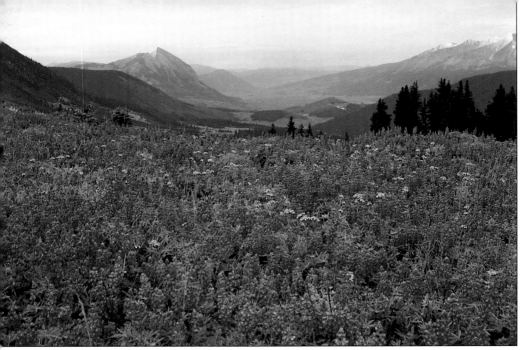

To successfully record the dimly illuminated foreground and bright sunrise sky in this photograph of a summer mountain meadow, I used a 4-stop graduated neutral-density filter to unify the exposure. Shooting in Crested Butte, Colorado, I exposed at f/16 for 1/8 sec. on Ektachrome 100 SW.

A 2-stop graduated neutral-density filter muted the bright reflection of the sky in a pond behind this summer seaside rose* in Maine. With a Zuiko 35-70mm lens set at 35mm, I exposed Ektachrome 100 SW for 1/60 sec. at f/8.

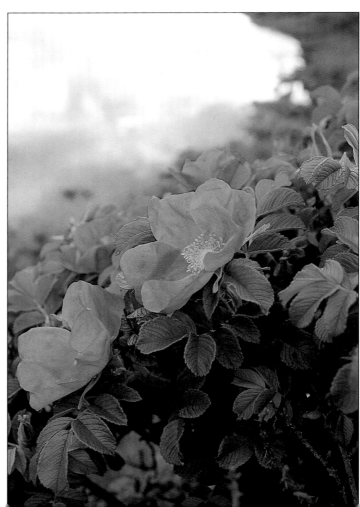

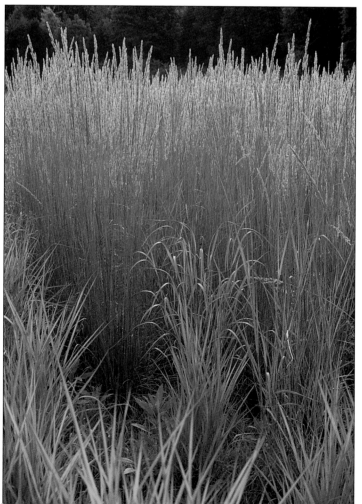

I used a 2-stop graduated neutral-density filter to intensify the dark summer thunderclouds hovering over this mountain landscape. Working in Crested Butte, Colorado, with a Zuiko 35-70mm lens set at 35mm, I exposed Ektachrome 100 SW for 1/30 sec. at f/11.

An 85 warming filter brought out the earthy colors in these autumn grasses in a New Jersey meadow. Here, I used a Zuiko 35-70mm lens set at 35mm and exposed Ektachrome 100 SW for 1/15 sec. at f/8.

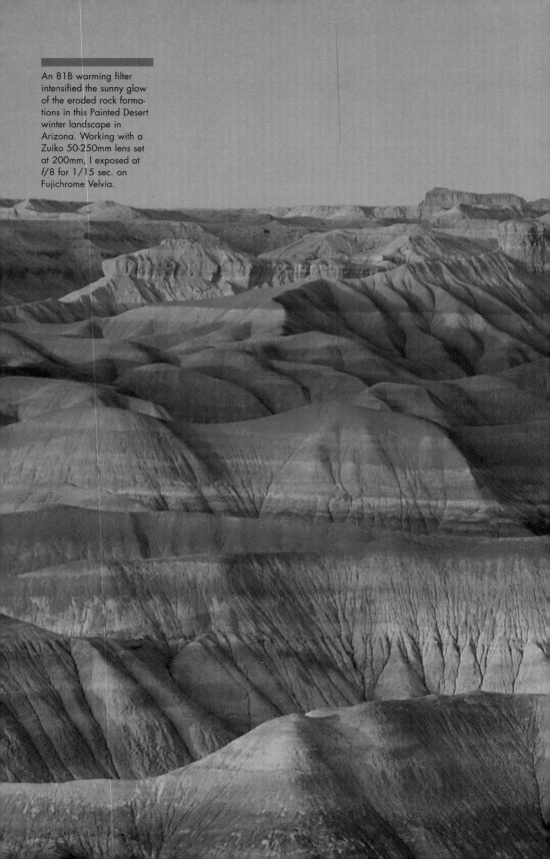

An 81B warming filter intensified the sunny glow of the eroded rock formations in this Painted Desert winter landscape in Arizona. Working with a Zuiko 50-250mm lens set at 200mm, I exposed at f/8 for 1/15 sec. on Fujichrome Velvia.

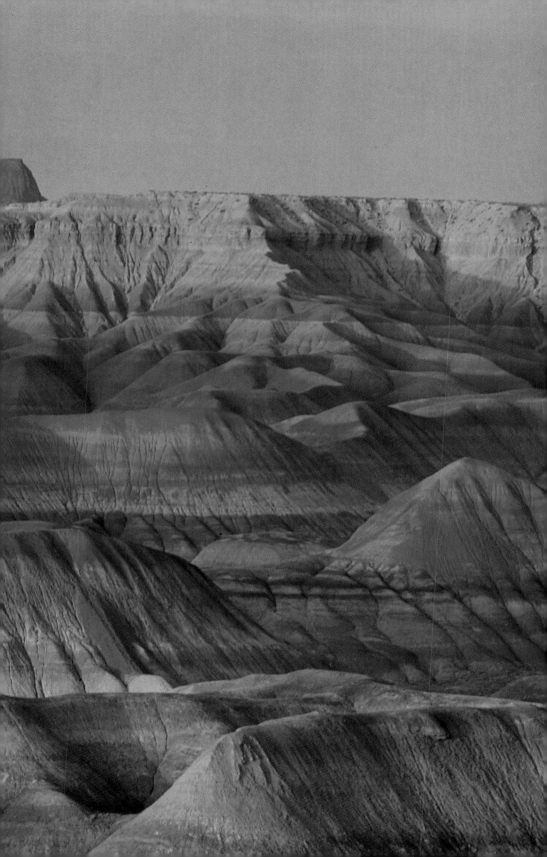

A soft-focus filter helped create a dreamy rendering of this riverside spring meadow in Holland. With a Zuiko 35-70mm set at 35mm, I exposed for 1/60 sec. at f/11 on Ektachrome 100 SW.

A mist filter softened the early morning light in this autumn silhouette of an elm tree in Kentucky. Shooting with a Zuiko 180mm lens, I exposed at f/8 for 1/15 sec. on Fujichrome Velvia.

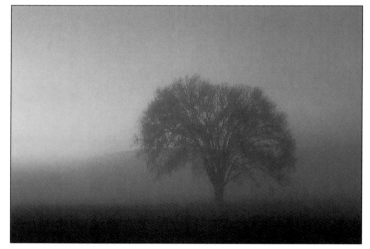

If you can't compose landscape shots that limit the presence of the sky by turning your camera downward, this filter can come to the rescue by darkening the upper portion of the image while leaving the lower part as is. The degree of darkening is indicated by a number. For example, a +2 graduated ND filter indicates that a 2-stop differential between the dark and clear areas. And you can choose from a variety to tonalities in the upper portion—gray, blue, or sepia—depending on how you want the sky to appear in your final image.

Warming Filters. These filters boost the warm tones that are characteristically found both in fall-foliage scenes and in shots taken at sunset. Warming filters also counteract the bluish cast of reflected light at high elevations, in forests, in snow, or near large bodies of water. Try the 81A (paler) or 81B (deeper) filters the next time you are in the mountains or near a lake, and see the difference they can make.

Soft-Focus Filters. Use these filters to soften an image and give it a dreamy, romantic aura. The exact effect will depend on the type of filter.

Check diffusion and fog filters of various intensities, and see which effect you prefer. They work especially well in bright, low-angled light that might seem too harsh. Try one of these filters in spring to soften pastels, particularly in backlight. You can also double up a soft-focus filter with a warming filter for interesting moody shots of fall foliage.

OTHER ESSENTIAL GEAR

Even though it sometimes feels as though there is no end to the equipment you can add to your photographic gear, it is possible for you to keep your collection relatively simple. And never lug so much gear that you become uncomfortable and tired or you won't enjoy your photography—and you'll probably give up too soon.

Think carefully about what to take on each outing based on what you expect to shoot, the kind of weather you are likely to encounter, how far you have to go on foot, and your own strength and tolerance levels. Also, keep in mind that the impact of your images depends much more on your vision and creativity than on apparatus. Here are the items, in order of priority, that you should take along.

Camera Bag. A good, sturdy, well-designed camera bag can make a great difference in the ease with which you find and use your camera, lenses, and other paraphernalia. A reputable camera shop should carry Tamrac and LowePro models, two excellent brands. The bag should be the right size: not too large or your gear will tend to bounce around, and not too small or your equipment might overflow and possibly fall out. Look for the kinds of compartments you need: thin compartments for filters, a flash unit, and a spot meter; and wide compartments for camera bodies and lenses. You should also look for snap-together and Velcro closures, and for a comfortable shoulder strap. (Backpack-style camera bags are good for carrying or transporting gear over long distances, but they aren't as easy to use in the field.)

A lens shade kept the rays of the setting sun out of the lens in this summer seascape shot along the North Carolina shore. Here, I used a Zuiko 24mm lens and exposed for 1/4 sec. at f/22 on Ektachrome 100 SW.

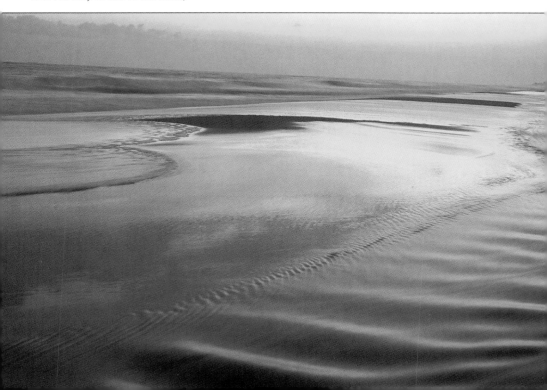

A handheld spot meter helped me gauge the exposure on the tiny foreground flowers; I wanted to make sure they would be bright enough to show against the summer landscape. Shooting in Washington's Mount Rainier National Park with a Zuiko 28mm lens, I exposed at f/8 for 1/125 sec. on Fujichrome 100.

Tripod. A sturdy, reliable tripod is essential to most nature photography. Landscapes, vignettes, and closeups depend on the steadiness only a tripod can provide. A tripod also makes it possible to bracket shots without worrying about unwanted changes in composition. Slow exposures of cascades and waterfalls are impossible without one. Invest in the best tripod you can buy, such as a Bogen or Gitzo model, and you'll enjoy using it for years to come.

Make sure that the tripod you plan to buy has a ball-joint head that lets you position the camera exactly as you want. Check that the ball-joint head moves smoothly and locks easily. The Linhof Profi models are excellent; less expensive but not quite as easy to use are the Bogen models. In general, bigger is better when it comes to ball-joint heads. But choose the size and weight you are most comfortable carrying.

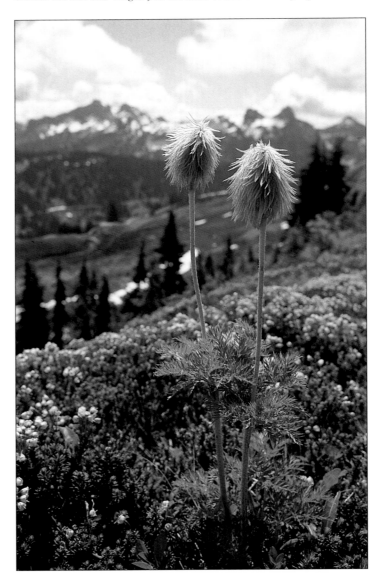

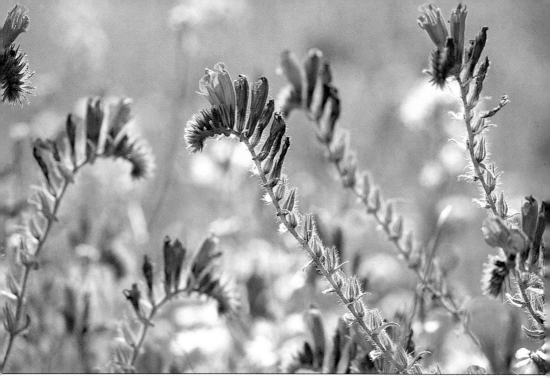

Lens Shade. This item prevents extraneous rays of light from marring an image with flare. When these light rays enter the lens, they produce streaks or bubbles of light on the image. Some photographs incorporate this effect in imaginative ways; usually, however, flare is a nuisance and distraction that photographers want to avoid.

Using a lens shade is especially important when you're shooting back-lit subjects when the sun is low in the sky. Each lens needs to be fitted for its own sun shade. In general, get a deep one rather than a shallow one; however, look through the lens to make sure you don't see any vignetting, where the shade shows in the corners or edges of the frame. This might be a problem with wide-angle lenses or if the lens shade is mounted on a filter.

Flash. An electronic flash unit that synchronizes with your camera is invaluable for closeups of nature. (For a complete description of full-power flash and fill-in flash techniques, see our companion volume, *The Field Guide to Photographing Flowers.*)

Spot Meter. For gauging exposure with pinpoint precision, you can't beat a handheld spot meter. This accessory enables you to make informed decisions about your exposure settings. Simply point the meter at a specific spot in the landscape, and take your reading. This is especially useful in high-contrast light situations where your camera would tend to take a center-weighted reading or a general reading, more or less averaging the various components. The Minolta F and the less expensive Sekonic spot meters are good choices.

Cable Release. While not absolutely necessary, a cable release is good to have any time you want to use a slow shutter speed. So take one along if you anticipate shooting waterfalls, if you want to experiment with the effects of wind, or if you're interested in trying your hand at night

A tripod was essential for bracketing and working with a powerful telephoto lens to get this detail of a spring bloom in Israel. With a Zuiko 300mm lens, I exposed for 1/250 sec. at f/5.6 on Fujichrome 50.

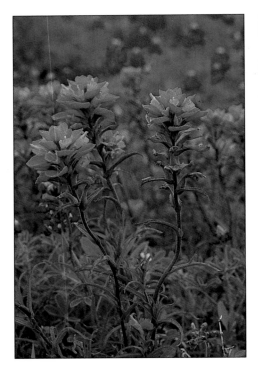 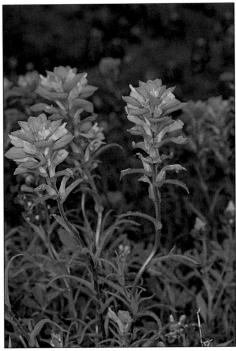

photography, including star trails. These are streaks that result from very long exposures made at night, showing the movement of the stars as the earth rotates.

Plastic Bags. Keep a few of these in your camera bag at all times. Grocery-size bags will protect your camera in case of unexpected rain or snow. Just wrap the entire camera body and lens in the bag, leaving an opening at the end of the lens. Use a rubber band to anchor the bag in place so you can shoot without worrying about your equipment in inclement weather. Bags that "zip" close are also handy for carrying exposed film and other small items you want to bring along.

YEAR-ROUND CARE AND MAINTENANCE

It is a good idea to develop a plan for maintaining your equipment season by season. This, of course, is in addition to the routine care you should give your gear after each outing. This should consist of a thorough drying and brushing off of the camera body and lenses. Taking a few minutes to remove any moisture, dust, sand, or grit will save you hundreds of dollars in repairs, to say nothing of the cost of frustration and disappointment when your camera doesn't work properly. Here are some ways to keep your equipment in tip-top shape year-round.

Spring Moisture. During the spring, the biggest challenge is to protect gear from moisture. With showers as common as they are at this time of year, you should always carry plastic bags just in case you need to cover your camera and lens (do this, of course, in any season when rain is likely). Protect the lens on your camera with a skylight filter. This filter has a very pale magenta cast that is used to eliminate or neutralize blue reflections from the sky. Many photographers keep skylight filters on their

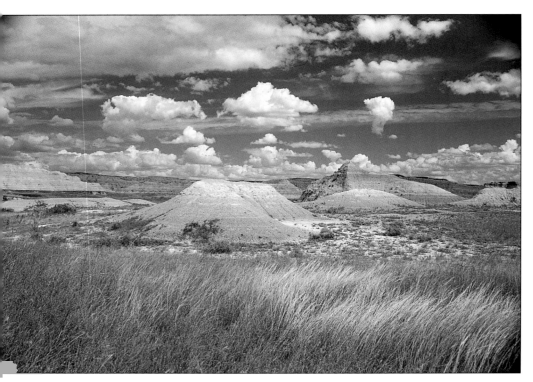

An 81A skylight filter protected the lens from blowing sand during a summer shoot at the Badlands National Monument in South Dakota. Shooting with a Zuiko 35mm lens, I exposed Ektachrome 100 SW film for 1/60 sec. at f/8.

lenses for protection against sand, water, and dust. Use zip-shut plastic bags for keeping film, extra lenses, and other small articles dry.

Also, carry a small towel or washcloth to dry your camera immediately in case you find that it has gotten wet. Moisture on the surface isn't cause for alarm as long as you quickly dry off the camera to prevent the moisture from seeping into the interior or any of the moving parts.

Summer Heat. Your primary task in the summer is to protect your film, including the roll in your camera, from heat. If you're traveling by car, keep your film in a styrofoam cooler. Place exposed film in a sealed plastic bag inside the cooler. Never leave film in the trunk or inside a car for more than a few minutes. Heat builds up more quickly than you can imagine.

If you're shooting near water or on a boat, take the "spring precautions" described earlier to keep your camera dry. In addition, be sure your camera bag is completely zipped when you aren't using it. This will keep water out in case the bag gets dunked or splashed.

Take extra care with sand. Keep all gear in sealed plastic bags until you are ready to use them. Carry a camel's-hair brush with you at all times, and brush off sand every time you finish a roll of film via the following steps.

 Go into a clean environment with no wind.
 Clean off the sand on your camera body and lens first.
 Open the film chamber, remove the exposed film, and brush out the film chamber gently before you load a new roll of film.

In a hot, humid environment, you must be especially vigilant if you're staying in an air-conditioned room. It might take 20 minutes for your

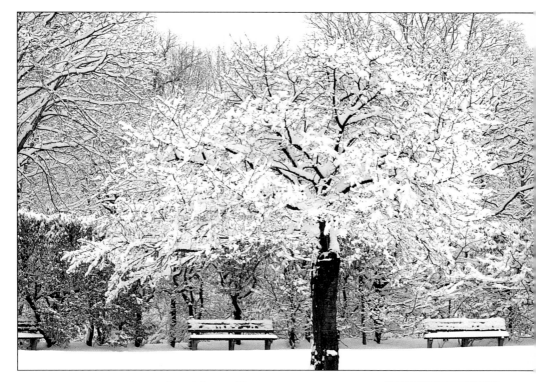

gear to get warm enough so it doesn't fog up. Keep your equipment in a closet far from the air conditioner. And take your apparatus outside to your car so it has time to warm up before you need to use it.

Fall Tuneup. This is the season to do a complete tuneup annually. Be sure to replace parts and making needed repairs. Routinely check your batteries, especially if you've been shooting all summer. They are likely to be low, and they'll need to be replaced before winter.

Do a thorough cleaning after a busy summer, and consider a professional cleaning if you've been shooting more than 50 rolls of film a month during the summer, especially if the conditions have caused a great deal of wear and tear. (Even if you shoot fewer than 40 to 50 rolls of film per month, you should have your camera professionally cleaned every two years.) Check if everything is functioning well, and bring any dubious items in for repairs. Get a clean bill of health for your equipment before the harsh conditions you are likely to face in winter.

Winter Cold. The name of the game in this season is protecting against cold—both you and your camera gear. Dress in layers to stay warm. Use rain pants and good boots with Gore-tex linings to protect your feet. Wear special polyurethane gloves that combine finger maneuverability with warmth. And wear thin gloves underneath any warm ones so you can manipulate your tripod easily even if it gets very cold.

Keep your camera warm when you photograph outdoors by carrying it under your parka until you are ready to shoot. Use plastic bags to protect equipment against falling and blowing sleet and snow. Check your batteries often, and replace them if they seem low, especially if you're working in below-freezing temperatures.

Carrying your camera under a parka and bringing along extra batteries are important precautions to take on winter shoots. I photographed this snow-covered tree at the New York Botanical Garden in the Bronx, New York. Shooting handheld, I used a Zuiko 50-250mm lens set at 100mm and exposed Fujichrome 50 for 1/250 sec. at f/8.

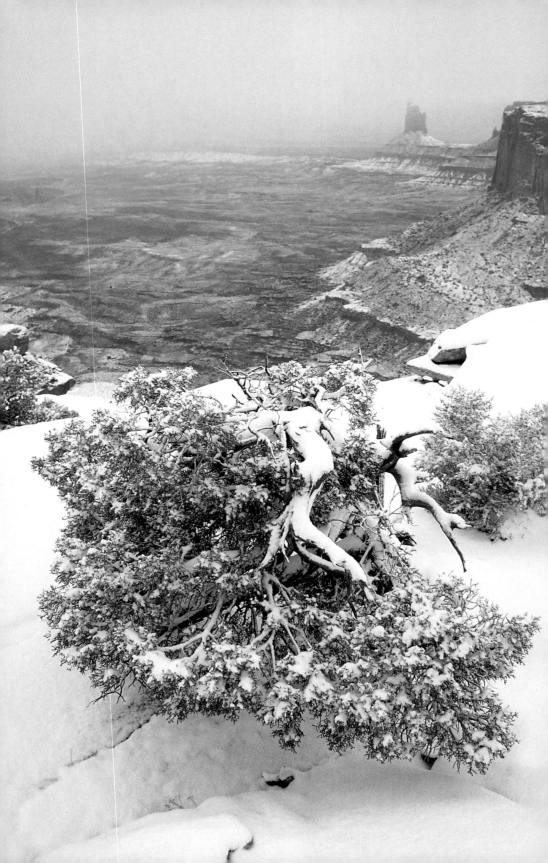

Compose with Clarity

For this winter composition, I needed a wide-angle lens to combine the weathered juniper tree with the snowy cliff edge and the more distant landscape. Working at Utah's Canyonlands National Park with a Zuiko 21mm lens, I exposed at f/11 for 1/30 sec. on Fujichrome Velvia.

My compositional strategy for this autumn field in Maryland was to use the sky and land as rectangular blocks, each with its own color and textural interest. With a Zuiko 35-70mm lens set at 35mm, I exposed for 1/15 sec. at f/16 on Ektachrome 100 SW.

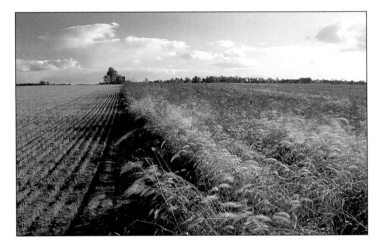

A photographer's vision is most discernible in the way an image is composed. Through composition you show how you're looking at the vast potential of the natural world and pointing to one piece of it for close consideration. The clearer you are about your composition, the more clearly your images will communicate your message. This requires the ability to impose order on chaos, to isolate a telling fragment from the complex fabric of nature, and to transform a subject by recognizing its potential for beauty and meaning.

The texture, line, and early spring colors of these agricultural rows in a California vineyard made them interesting photographically. Here, I used a Zuiko 50-250mm lens set at 200mm for 1/60 sec. at f/8 on Fujichrome 100.

Artists and photographers have always shaped reality to their individual aesthetic purpose, sometimes subtly and sometimes brazenly. Often, they've disagreed about how to organize and balance the visual elements so the composition works. To some degree, they've flirted with discovering the charm in something accidental. And certainly finding the right composition involves an element of trial and error. This isn't to say that good composition is a matter of chance. This chapter attempts to make you more aware of the strategies for thinking about composition, as well as how to use them toward your own ends.

BEAUTIFUL OR PHOTOGENIC?

Begin by sweeping away a common misconception: that the beauty of a photographic image depends on the beauty of the subject. Not so. Yes, if you go to magnificent locations, you have a chance to depict their splendor. But more bad pictures of the Grand Canyon exist than good ones. And everyone has seen absolutely charming images of weathered barns and faces, images whose impact hardly depends on the surface beauty of their subjects.

By analyzing successful images of subjects that aren't inherently beautiful, you can discover some of the values that make them work as photographs. In other words, you'll grasp what makes a subject photogenic. Those values might include strong lines, a dramatic shape, interesting patterns and textures, colors with character, or a special aura of light.

Any one of these values might be enough to make a subject photogenic. Several together might make it magnificent. The key, however, is the strength of any one value, rather than the number of different kinds of values, that you can encompass within one frame. Think of each frame as a gem that you're trying to refine and polish. It will shine depending on how well polished each facet is, not by how many facets it has. You can achieve that polish in your compositions various ways.

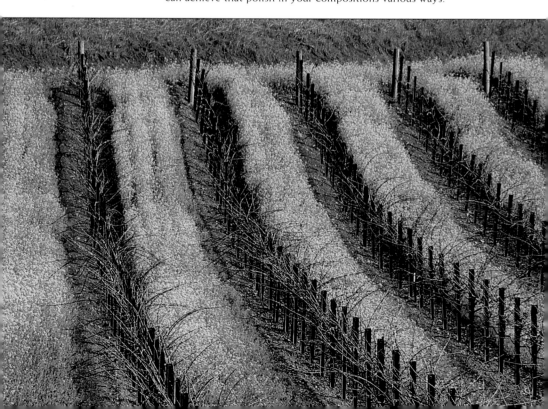

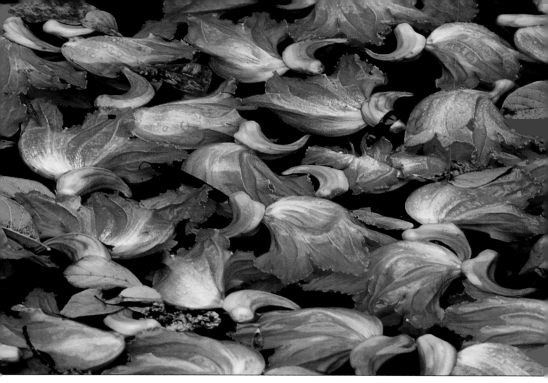

FORMAT AND FRAMING

The first act of composition is framing. When you frame an image, you select a small portion from a vast array of possibilities. Begin by thinking about your format. Since most cameras are designed to be held in a horizontal format, photographers tend to favor this orientation. However, that isn't necessarily the most effective format to choose. Develop the habit of looking at each subject in both horizontal and vertical formats. You might even want to shoot in both directions until you have a better sense of what works in various situations. But at the very least, look at your subject both ways.

Next, think about a variety of perspectives on your scene. Many photographers gravitate toward a single point of view. They might shoot only broad scenic expanses or home right onto a single flower. To expand your repertoire, remember to shoot at least three kinds of images.

Overviews. These compositions encompass the broadest perspective. They serve as establishing shots that identify the location, but they can also be artistic. Using your standard to wide-angle lenses, look for lines and shapes that will help define the large area and give the eye a focal point. To produce a feeling of depth in overviews, compose with converging lines, such as an allee of trees. Another option is to create a flat, abstract impression by composing with graphic shapes, such as rocks, blocks that the land and sea form, and shadows.

Vignettes. These compositions focus on intimate landscapes. Think of them, and shoot them, as you might a family portrait, using mostly standard to moderate telephoto lenses. Arrange the elements so that the individual characters maintain integrity—retain their individual identity and value—while forming a whole that stands up to scrutiny. Balance the shapes within the frame, and play up contrasts of color or texture. Put a premium on sharpness and clarity throughout the frame.

These fallen flowers from a tulip tree weren't apparently beautiful, but as they floated in a pond they looked quite photogenic, as this closeup of their vibrant autumn colors and repeated shapes shows. Shooting in Hawaii with a Zuiko 35-70mm lens set at 50mm, I exposed Ektachrome 100 SW for 1/15 sec. at f/16.

The lines and textures in this abstract detail of a backlit leaf filled this horizontal-format frame. With a Zuiko 50mm macro lens, I exposed for 1/4 sec. at f/22 on Fujichrome 100.

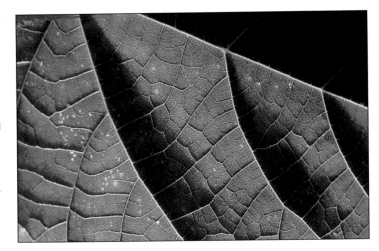

I chose a vertical format to create a pleasing arrangement of shapes in this summer grouping of Colorado marsh marigolds. Shooting with a Zuiko 90mm macro lens, I exposed Fujichrome Velvia for 1/15 sec. at f/16.

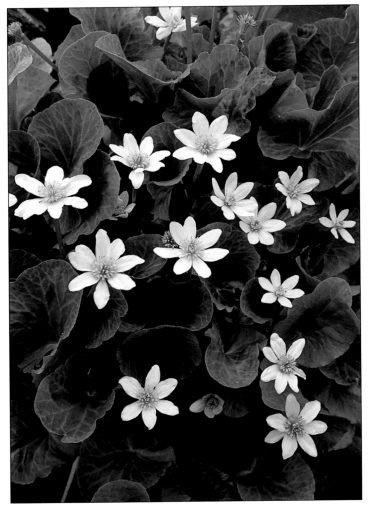

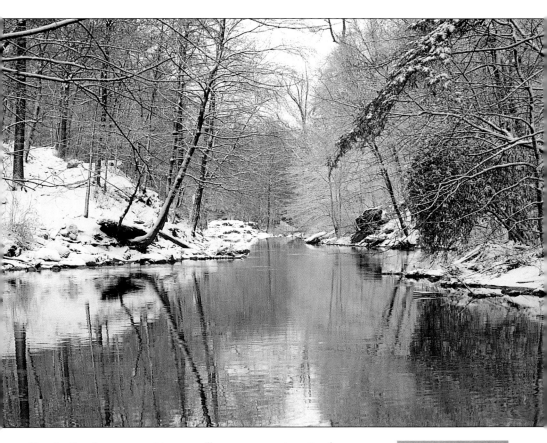

Details. For these compositions, you'll want to come in quite close, so turn to your macro and telephoto lenses. Work with subjects that can stand alone because they have strong lines and shapes. Isolate your subject from its surroundings, either by framing very tightly or by throwing the background out of focus with a limited depth of field.

LINES AND SHAPES

A composition has balance according to the configuration of lines and shapes within the frame. Too often photographers become so dazzled by their subjects that they neglect to consider the more abstract qualities of their images. So remember to think of flowers and trees as shapes within the frame, and look at hills and valleys as lines along the horizon. Only then will you best use the natural resources before your eyes.

Next, contemplate how best to arrange those lines and shapes. Lines can be straight, curved, or irregular. Straight lines, such as the horizon against the sky, can divide the frame horizontally. They can also form a diagonal for a more dynamic effect. They can converge to create a sense of depth, or they can be vertical, such as tree trunks in a forest. Curved lines can sweep the viewer's eye into the interior of a scene, while irregular lines can add whimsy to a composition.

Nature is full of geometric shapes, so pay close attention to how they fall within your frame. The land and sky can constitute large, rectangular shapes; flowers are often round or oval, or form radii from a central hub. Rocks can be rounded by the sea or form massive outcrops in a landscape.

A horizontal format captured the breadth of the Bronx River at the New York Botanical Garden, showing the wintry shoreline and its reflections. Working with a Zuiko 35-70mm lens set at 70mm, I exposed at f/11 for 1/125 sec. on Fujichrome 50.

(Overleaf) The lines of the landscape and the repeated shapes of the haystacks helped structure this summer scenic in Colorado. Here, I used a Zuiko 50-250mm lens set at 150mm and exposed for 1/30 sec. at f/11.

A telephoto lens flattened this French summer landscape into two irregular shapes, the rows of lavender above and the green field below. The gnarled trees offered a compositional focal point. Shooting with a Zuiko 50-250mm lens set at 200mm, I exposed at f/8 for 1/60 sec. on Kodachrome 25.

The bare branches of magnolia trees stood out as strong lines against this snowy setting at the New York Botanical Garden in the Bronx. With a Zuiko 50-250mm lens set at 100mm, I exposed at f/11 for 1/125 sec. on Fujichrome 50.

And the contours of the land can form all sorts of shapes. Of course, many natural scenes combine disparate lines and shapes. As you become used to looking for them, you'll be able to judge more clearly whether or not they produce an effective composition.

PATTERNS AND TEXTURES

Another compositional element derives from patterns and textures. Nature tends to repeat itself. The stones along the beach, the grasses in a meadow, the trees in a woods, and the ripples on a lake all come in multitudes forming patterns that can enhance your images. If you look more closely still, you'll find rich and intricate textures in those repetitions. Search for the textures in a hillside of bare trees in late autumn or winter. Move close to the bark of a tree. Discover the lush greens of a ground cover in a forest. These and many other subjects are worth exploring with your camera.

I built this closeup on the repeated patterns and textures of a mass of monarch butterflies clinging to a tree in winter. Shooting in Mexico with a Nikkor 200mm lens, I exposed Fujichrome Provia for 1/30 sec. at f/16.

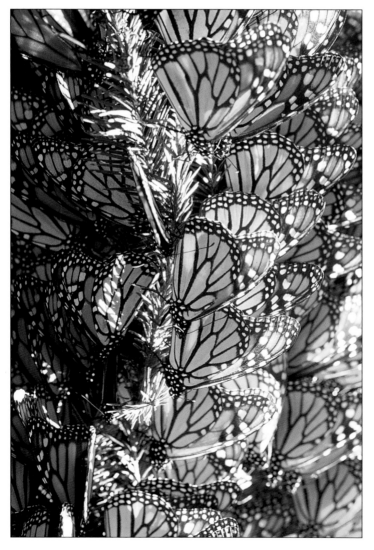

The lacy texture of bare aspen trees on a late-fall Colorado hillside filled the frame in this telephoto shot. Here, I used a Zuiko 50-250mm lens set at 250mm and exposed Ektachrome EPP for 1/125 sec. at f/8.

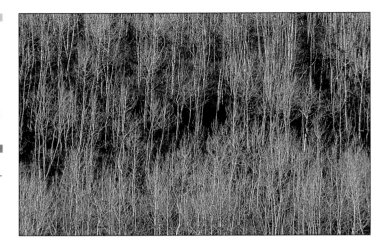

The texture and lines of long summer grasses growing in this birch grove in Maine created a foreground focal point in this vignette. Working with a Zuiko 24mm lens, I exposed at f/16 for 1/15 sec. on Fujichrome 50.

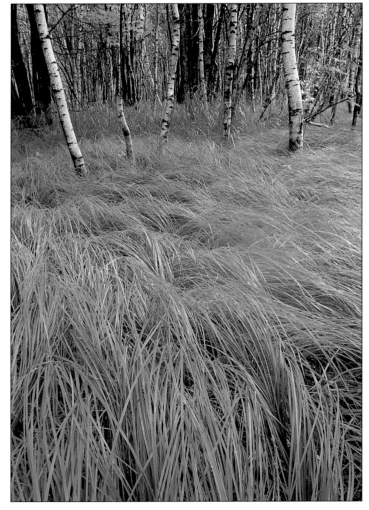

When you do, incorporate the patterns and textures as the focal point of your composition. This will create a simple but intriguing abstract. Another possibility is to make them another dimension of a broader perspective, with the pattern or texture as an introductory element at the base of the frame. Remember that sharpness and clarity are paramount to featuring textures. Take the necessary time to focus very carefully, and use a small aperture to maximize depth of field.

FILL THE FRAME

Before you release the shutter, take a slow and careful tour of your entire frame. Be sure to look at the edges and into the corners. Check that you haven't included some distraction, such as a point of bright light or a disturbing background object. If you have, find a way to eliminate it by reframing, moving slightly, or throwing it out of focus. Try to keep within the frame only what is necessary to your image.

For landscapes, think about whether or not to incorporate the sky. If it is a bright blue and has interesting clouds, the sky can play a major

A single magnolia bud filled the frame in this floral closeup. Shooting in Louisiana, I used a Zuiko 90mm macro lens to blur the spring setting. I exposed Fujichrome Velvia for 1/15 sec. at f/5.6.

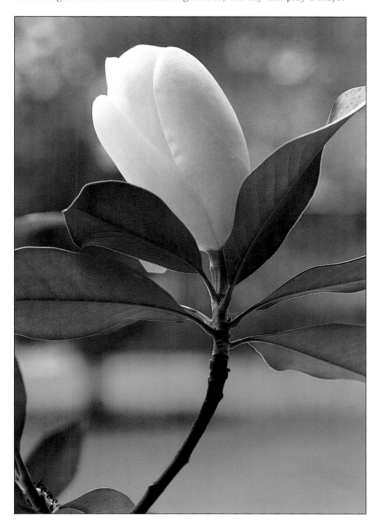

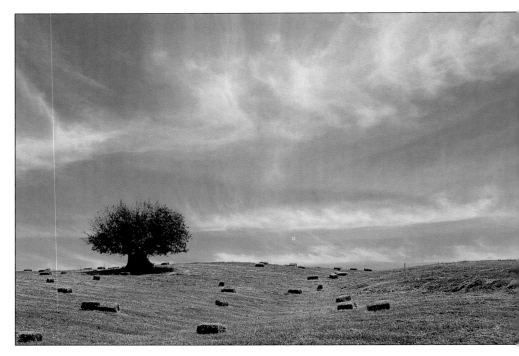

Ordinary elements of land and sky can fill the frame if they offer interesting color and texture, as in this stripped-down summer image, punctuated by a single well-formed tree. Working in Spain with an Olympus IS-3 camera set at 35mm, I exposed at f/11 for 1/250 sec. on Fujichrome Velvia.

role in your image. But if it is dull and lifeless, you are probably better off limiting or eliminating it entirely. Also, be sure that the key subject of your image is large enough to make an impact. If you're framing a single flower, it should fill the bulk of the frame or even extend beyond the confines of the frame, instead of floating in its surroundings. If you can't get close enough to frame a single flower tightly, consider another option. Perhaps you can effectively frame a group of flowers for good composition.

Until this becomes second nature, you might want to put your idea into words, and check that what you're framing represents exactly what you intend. For example, suppose you want to show the brilliant yellow foliage in an autumn scene. Check that your image really says "yellow foliage" right across the frame. This is a relatively simple step that many nature photographers don't bother to take. Developing this kind of discipline will pay off in shots that contain much greater clarity and better compositions than "unchecked" images.

ABSTRACTIONS

Once you've honed your compositional skills, you might even be interested in trying some shots that are outright abstractions. These images utilize subjects from nature in an essentially unrecognizable way to create images of pure form, line, and color. While such images aren't likely to become the mainstay of your photographic repertoire, they are excellent exercises, as well as fun ways to approach your subject. And they make beautiful and intriguing prints to hang on a wall—often more so than more documentary depictions of nature.

Abstractions also lend themselves to black-and-white photography. You might want to try this in order to learn how to emphasize form, line, and shape. But color, though challenging, remains the fascinating mainstay of nature photography.

The trunks of this stand of evergreen trees in Wyoming's Yellowstone National Park filled the frame with monochromatic winter tonalities, vertical lines, and rough textures. Shooting handheld with a Nikkor 80-200mm lens set at 200mm, I exposed Fujichrome 100 for 1/125 sec. at f/4.

Looking closely at tree bark can yield interesting abstractions, as in this shot taken at Winterthur Garden in Wilmington, Delaware. Working with a Zuiko 90mm macro lens, I exposed at f/22 for 1/15 sec. on Ektachrome 100 SW.

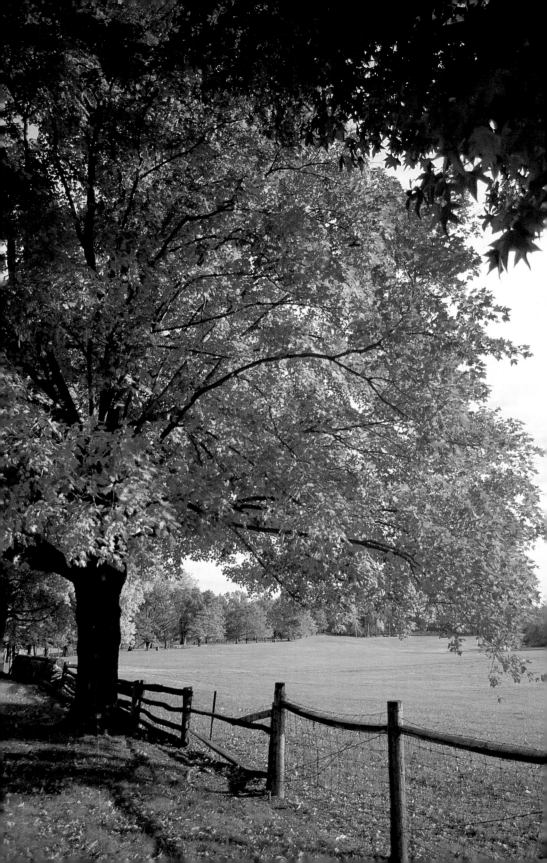

CHAPTER 4

Seasonal Colors

To create the rich reds and oranges of this Virginia sugar maple in autumn, I combined Ektachrome 100 SW film with an 81B warming filter and a polarizing filter. With a Zuiko 35-70mm lens set at 35mm, I exposed for 1/125 sec. at f/8.

I recorded the spring greens of a roadside meadow in Holland by overexposing 1/2 stop from a general meter reading. Working with a Zuiko 50-250mm lens set at 150mm, I exposed at f/8 for 1/30 sec. on Fuji-chrome Velvia.

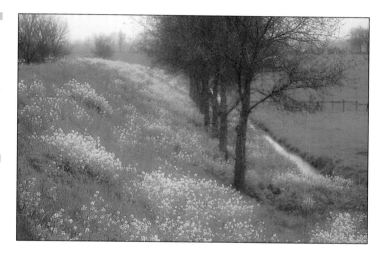

W hile certain photographic concepts, such as composition, transcend seasonal variations, others are more closely tied to specific seasons. The color palette of the natural world changes markedly from season to season. You can easily recognize that the fiery tonalities of autumn differ from the grays and browns of winter. Even the greens of spring are distinguishable from the greens of summer.

But beyond the visible color transformations that occur from season to season, you have to contend with two other issues: using colors as a conscious part of image design and mastering the technicalities of rendering colors in the best way possible. Questions of design ultimately are matters of individual judgment. To help you think about the role of color in design, you might want to consult an art textbook. In general, though, colors are discussed in terms you should become familiar with: warm versus cool tones; bright, vibrant colors versus soft, pastel colors; and contrasting colors versus a monochromatic palette.

COLOR RENDITION

For nature photographers, one of the greatest challenges concerns color rendition. Unlike a painter who can select or mix colors to produce the desired effect with precision, photographers depend on a combination of factors that can limit or expand their ability to produce the exact colors they want. These include the choice of film, the lighting conditions (see Chapter 5), and the combination of colors in the image subject.

The more uniform the lighting conditions, the truer your colors are likely to be, barring the influence of unrelated colors in the surroundings. But even in uniform light—and especially in high-contrast light— decisions about exposure will play a key role in determining color rendition in your final image. Therefore, meter as precisely as you can the specific subject whose color rendition you care most about. Use that reading as the basis for your exposure, but always bracket to ensure the best possible color presentation. Select film for its color rendition, and use filters that will help you control colors according to your preferences.

Remember, too, that the more similar in value the colors, the easier they'll be to portray accurately. Conversely, the greater the contrast in tonalities between colors, the harder it will be to get good rendition of all colors. This has mostly to do with the latitude of the film, which is its capacity for handling extremes of light and color. So before you go out

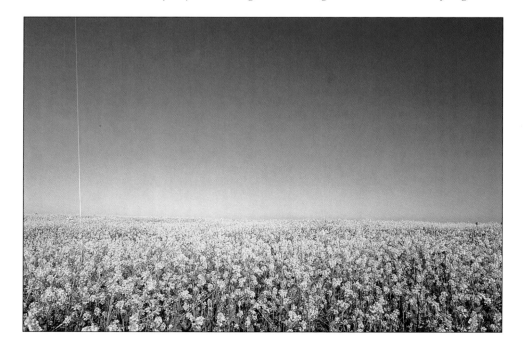

on a shoot, think carefully about the kinds of colors you are likely to encounter and bring along film that works well with those colors.

Finally, take into account the emotional impact of the colors in your image. Some colors, like red, tend to excite. Others, like pale blue and green, tend to have a calming effect. Try to unify the colors enough so they serve your overriding purpose. If, for example, you want to reveal the delicate softness of a field of wildflowers, you must be sure that the light and the surroundings don't compete too much with the wildflowers.

SPRING'S HUES OF RENEWAL

The fresh greens of spring are just one symbol of this season of renewal. The dominant mood is one of resurgence and rebirth. Not surprisingly, the colors that most convey this youthfulness are pastels. Indeed, the greens of early-spring grass and the first buds of leaves are decidedly softer and paler than those that emerge by the summer.

Flowering trees, such as magnolias and dogwoods, as well as woodland wildflowers, lean toward pale shades of pink and white. To best capture these fresh pastels, you might need to overexpose by 1/2 to 1 full f-stop from the meter reading. Overexposure compensates for the camera's tendency to render all colors toward the middle tones. So shoot at the meter reading, and then bracket by half stops toward overexposure.

You should also bracket whenever you face a mix of color intensities, such as a bed of multicolored tulips. In general, such situations are best handled by exposing for the lightest colors, even if this means the brighter ones will be somewhat deep. Bracketing will give you several good renditions to choose from.

Very bright light can overwhelm delicate pastels so try to shoot in diffused light. You are more likely to find that light on slightly overcast days, right after a rainfall, or early in the morning, particularly if there is some mist. If you have to shoot in bright sunlight, bring along diffusion filters or a white umbrella to reduce the light intensity.

Under soft, uniform light diffused by a thin cloud cover, I captured the spring pastels of this cherry tree with Kodachrome 25, which is slightly magenta. Shooting in New Jersey with a Zuiko 50-250mm lens set at 200mm, I exposed at f/8 for 1/15 sec.

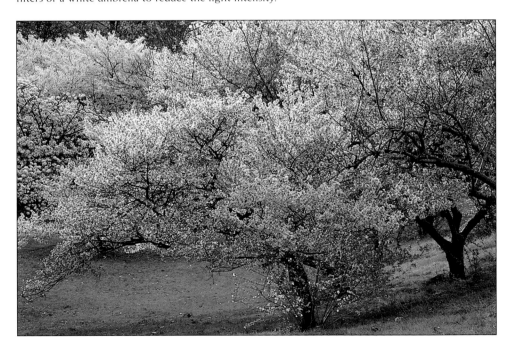

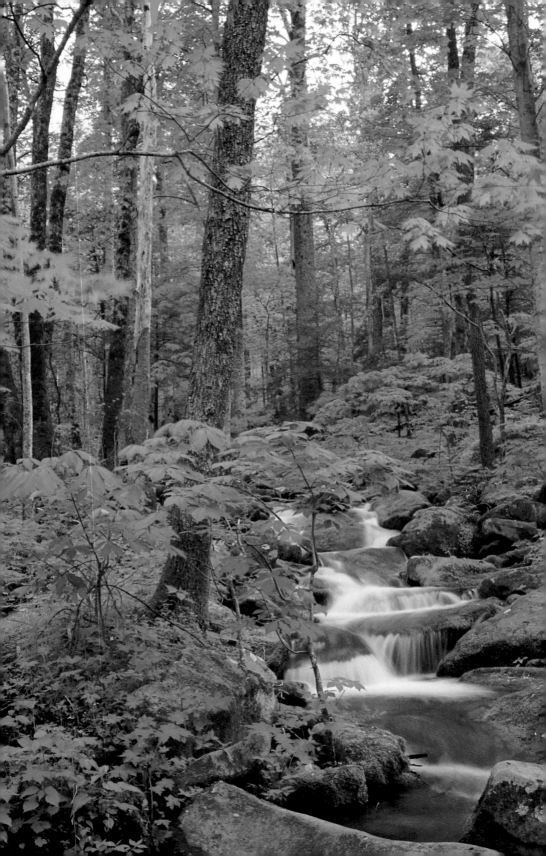

The best films for soft spring colors are Fujichrome Provia and Kodak Ektachrome 100 SW. These films retain the integrity of the colors so they don't wash out or fade. They also give pastels a glowing aura that is quite flattering.

SUMMER'S PALETTE OF VITALITY

Summer colors tend to be bright and vibrant. They include strong reds, deep greens, and other colors that look best when fully saturated. It takes a bit of finesse to keep these colors true and prevent them from washing out, especially in very bright sunlight. You should expose on the middle to brighter tones in the image. Polarization might help. Bright overcast days make it somewhat easier to get true colors, but you must be aware of the impact of the sky. Here are some additional suggestions.

To begin, work with a polarizer on all your lenses. This will reduce or eliminate unwanted glare, which dulls colors and leaves an unattractive shine on foliage and other reflective surfaces. Also, give some thought to

I enhanced these vibrant spring greens with Fujichrome Velvia and a polarizing filter to remove unwanted reflections in this scenic of Tennessee's Great Smoky Mountains National Park. Shooting with a Zuiko 35mm lens, I exposed for 1/30 sec. at f/22.

To accurately capture the rich bluish purple of this mountain meadow of summer lupines, I used Fujichrome Provia; I accentuated the color by muting the bright sky with a neutral-density filter. Working in Colorado with a Zuiko 28mm lens, I exposed at f/16 for 1/4 sec.

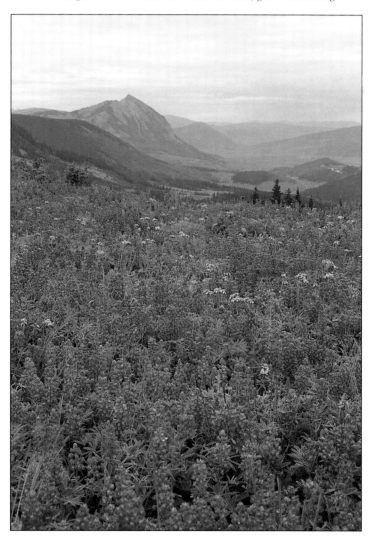

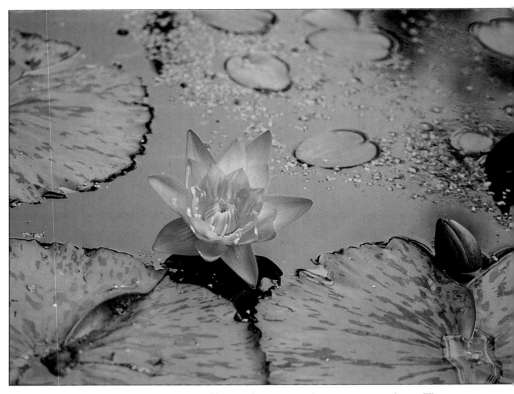

Soft lighting and a polarizing filter helped bring out the greens of the autumn lilypads, the orange of the flower, and the slate gray of the water in this pond in New York. Shooting with a Zuiko 300mm lens, I exposed Ektachrome 100 SW for 1/60 sec. at f/5.6.

using warming filters to bring out red tones in your subject. This is especially important when you shoot in the low-angled light of early morning, which often has a bluish cast, and when you want to enhance the warm tones of sunset light.

It is always wise to bracket exposures, particularly in the summer when you face complex, often harsh lighting conditions. Bright backlight and glare, as well as subjects that are much brighter than their backdrops, might cause colors to be underexposed. To prevent this, take a closeup reading of your main subject, if possible, or use a spot meter from a distance. Then lock in that reading before you shoot. In addition, you might want to bracket toward overexposure or use your camera's "backlight" mode, if it has one. Also, bracket toward underexposure to compensate for any complicated lighting problems and to ensure the best possible color rendition in at least one shot.

For strong colors, the films of choice are Fujichrome Velvia, Kodak Ektachrome 100 S, and any Kodachrome film in the ISO 25-200 range. These will render the greens and reds of summer with wonderful intensity, but the exact colors vary from film to film so test one roll of each to find your preferences.

FALL'S SHADES OF SPLENDOR

No season is more noted for its colors than autumn. The glowing splendor of fall foliage draws visitors from many miles away, for no other reason than to see those wondrous fiery tones. To capture the rich and warm yellows, reds, and oranges of autumn, concentrate on working with light that enhances these colors. The warmest light is toward sunset, though early-morning light can also be flattering. Also, plan to take shots

The low-angled light of the setting sun on this marsh warmed the tawny fall colors of these grasses. Shooting handheld with a Zuiko 35-70mm lens set at 40mm on Maryland's eastern shore, I exposed for 1/60 sec. at f/4.5 on Ektachrome 100 SW.

Bright, overcast light made it easy for me to record the rich autumn colors of an oak tree in this Tennessee woodland. Here, I used a Zuiko 50-250mm lens set at 250mm and exposed at f/8 for 1/15 sec. on Ektachrome 100 SW.

using backlight, which passes through foliage, giving it the glow of stained glass.

Use a polarizer to reduce glare and to bring out the vivid colors of the season. And consider using a warm-tone polarizer to emphasize these colors even more. If you like, you can also experiment with warming filters, especially on overcast days.

You can intensify fall colors by using your telephoto lenses, which appear to compress space so subjects that are a distance apart seem closer together. For example, the foliage of aspen trees might not be dense enough to convey its dazzling yellow. But when shot from a distance with a telephoto lens, the leaves seem massed, which makes their color have a greater impact. With your telephoto lenses, home in on a vignette or a detail rich in color interest. The best films for fall's warm tonalities are Ektachrome 100 SW, a film noted for its radiant glow, and Fujichrome Velvia, a high-contrast film that makes colors brilliant and energetic.

WINTER'S MAGNIFICENT MONOCHROMES

The beauty of winter colors is in their subtlety. This is the season when whites, browns, and grays dominate, their neutral tones holding their own in soft winter light. Grays and browns don't pose serious exposure problems, nor do the touches of color you find in evergreen trees and

These fallen autumn leaves would have looked considerably duller without an 85 warming filter. Shooting in New York with a Zuiko 90mm macro lens, I exposed at f/8 for 1/15 sec. on Ektachrome 100 SW.

Soft backlighting made this bright red sumac glow, and Fujichrome Velvia helped to saturate the fall colors and increased the contrast with the backdrop. Working in Vermont with a Zuiko 50-250mm set at 180mm, I exposed for 1/30 sec. at f/8.

The light of the setting sun added soft pinks and blues to an otherwise stark winter seascape photographed off Cape Cod. Shooting in Buzzard's Bay, Massachusetts, with a Zuiko 24mm lens, I exposed Kodachrome 25 for 1/8 sec. at f/16.

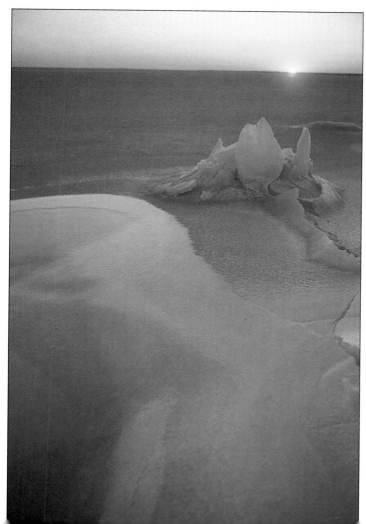

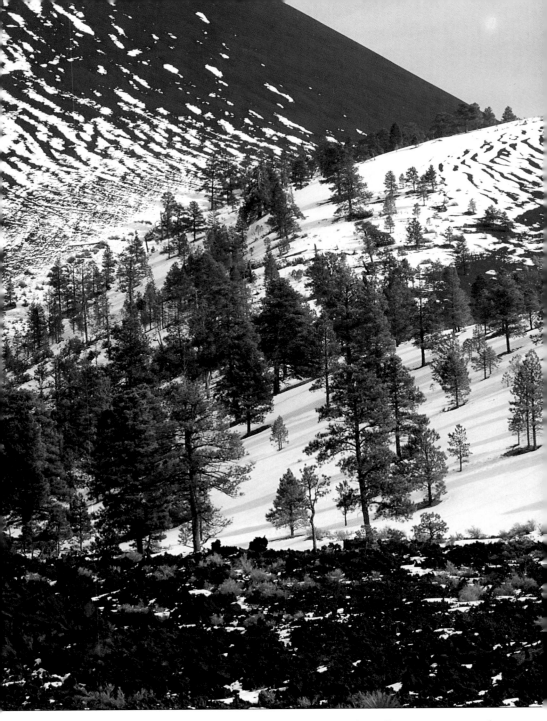

winter berries. The hardest color to render well in winter scenes is the white of snow. Because overcast illumination is easier to work with, don't hesitate to shoot when a cloud cover exists. Even then, you might need to overexpose slightly to prevent the snow from turning gray.

Exposure on snow is trickier in bright midday light. If you don't mind seeing a bluish tinge on snow in your images, try shooting Ektachrome

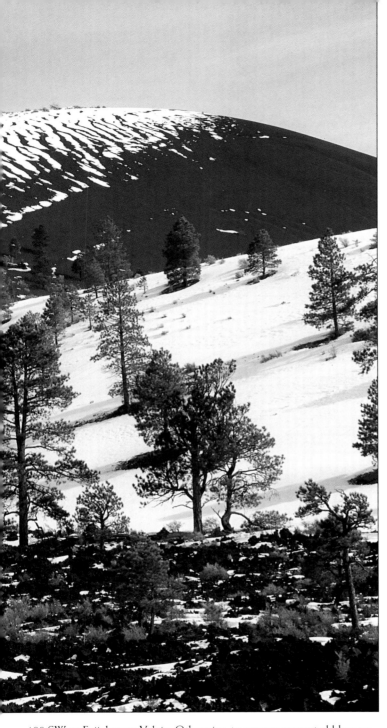

This snow-dusted, black volcanic setting in Sunset Crater State Park in Arizona emphasized the black-and-white tonalities of winter, which the diffused light enhanced. Shooting handheld with a Zuiko 50-250mm lens set at 150mm, I exposed Fujichrome 100 at f/8 for 1/125 sec.

100 SW or Fujichrome Velvia. Otherwise, to remove unwanted blues or reds, you might need to turn to a 1A or 1B skylight filter, or the 10 CR, a slightly red filter that some professional photographers use for color correction. As for films, Kodachrome tends to give snow a magenta tinge, while Fujichrome Velvia is especially good for adding contrast if you feel the scene is too uniform in color.

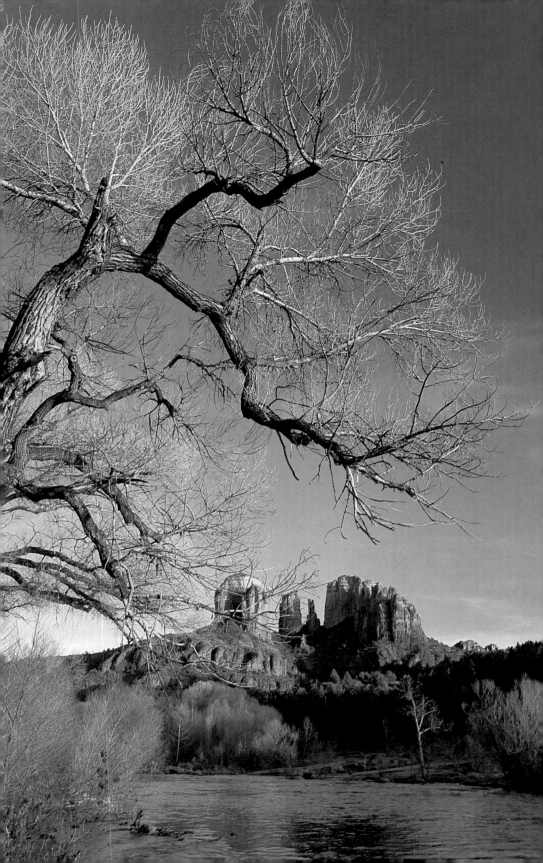

The Light Fantastic

Strong, low-angled sunset frontlighting cast a warm glow on this barren cottonwood tree set against a wintry landscape. I intensified the colors by using a polarizing filter and underexposing by 1 stop, shooting at f/11 for 1/30 sec. on Kodachrome 25. Working in Sedona, Arizona, I used a Zuiko 24mm lens.

I spotlighted the dramatic sunset sidelighting on these autumn aspen trees through polarization and 1 stop of underexposure. This unusual perspective, shot with an ultrawide-angle lens, added to the impact of the light. Shooting in Utah with a Zuiko 21mm lens, I exposed Fujichrome Velvia for 1/15 sec. at f/16.

Just as each season presents its distinctive color palette, it also projects a characteristic light quality, above and beyond the variations that occur throughout the day and with changes in weather and atmospheric conditions. Keep in mind that light is the essential raw material of the photographic craft. The quality of light can transform an ordinary scene into an extraordinary one; uninspiring light can dull the most dramatic setting.

Because I used a polarizing filter and underexposed by 1 stop, the very bright midafternoon light didn't bleach out the radiant fall foliage on this majestic oak tree in Ohio. With a Zuiko 50-250mm lens set at 180mm, I exposed at f/11 for 1/30 sec. on Fujichrome Velvia.

Within a matter of hours on a summer day, two different kinds of light illuminated this mountain meadow in Colorado. This first shot, taken at 7 A.M., shows soft, diffused light, which brightened the greens. I used a slow shutter speed to turn the moving stream water milky white. Working with a Zuiko 50-250mm lens set at 200mm, I exposed for 1/8 sec. at f/16 on Fujichrome Velvia.

When I took this second shot at 9 A.M., the sun had risen and the light became quite intense, highlighting the flowers in the meadow. I selected a faster shutter speed, 1/30 sec., to freeze the movement of the stream. Here, I used the same 200mm setting on a Zuiko 50-250mm lens and Fujichrome Velvia but exposed at f/11.

As a nature photographer, you must sensitize yourself to the light at hand and learn to make the most of what is available. And, if you recognize that the existing light makes your picture-taking pointless, you might have to accept the limits of what you can do or try to come back at a more auspicious time.

How can you develop a special sensitivity to the qualities of light and to the particularities of the light at each season? First, look at light more analytically and cultivate a greater awareness of the character of each kind of light. Then, use the suggestions in this chapter and work toward capturing the unique aspects of that light on film, while overcoming the difficulties inherent in each type of light. To analyze light more effectively, begin by noticing three elements: intensity, direction, and color.

INTENSITY

Light can range from very bright and high contrast to dim, even dull, and low contrast. In general, it is easier to photograph in low-contrast light, ideally with some brightness to it, than high-contrast light. Low-contrast

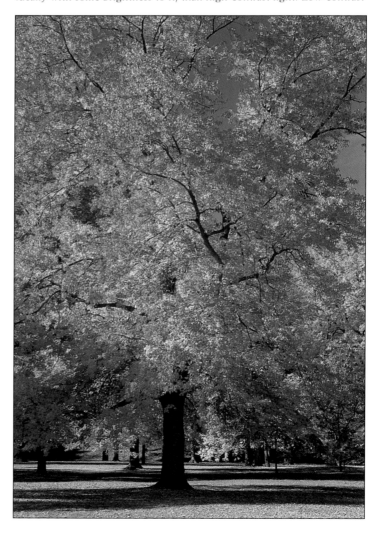

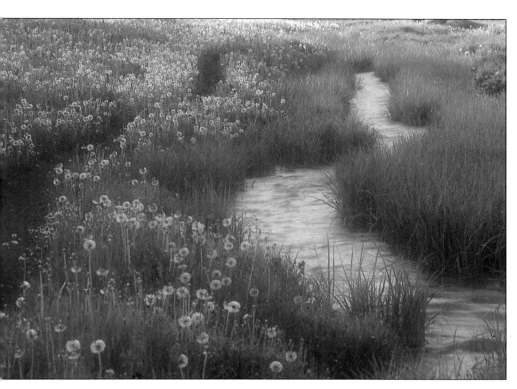

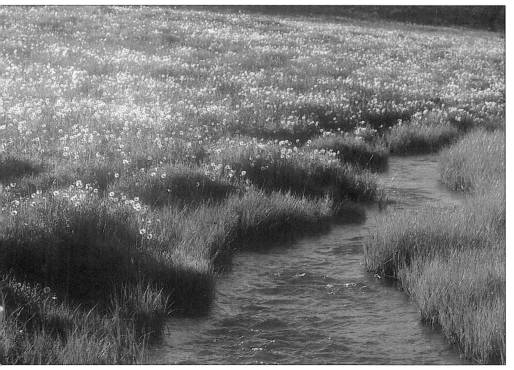

Using a polarizing filter on the afternoon frontlight on this red sugar maple cut the reflections and saturated the fall color. Shooting handheld in Virginia with a Zuiko 35-300mm lens set at 35mm, I exposed for 1/125 sec. at f/5.6 on Fujichrome Velvia.

I photographed this bare cottonwood tree in Sedona, Arizona, in both afternoon frontlighting and morning backlighting one winter to illustrate the direction of light. For this frontlit image, I underexposed the tree by metering the sky and shooting at that reading. Working with a Zuiko 24mm lens, I exposed Kodachrome 25 for 1/15 sec. at f/11.

To create a silhouette of this backlit scene, I underexposed from a meter reading of the sky. Here, I used the same Zuiko 24mm lens but exposed Fujichrome Velvia for 1 sec. at f/16.

light is often referred to as diffused light, the kind you encounter on a bright overcast day or can produce by filtering sunlight through a white screen (see page 106).

DIRECTION

The direction of light refers to where the source of light is with respect to the subject and camera.

Frontlight strikes the subject head on, with the camera facing the illuminated side. This type of illumination can be harsh, but it also puts a subject in the spotlight. If you don't like this effect, shoot when the illumination is low-angled.

Backlight comes from behind the subject, with the camera facing the light source and shadow side of the subject. This kind of light gives the subject a translucent glow that is quite appealing, or serves to create silhouettes.

With sidelight, the camera is at an angle of about 90 degrees to the light source and faces the subject, which as a result is partly illuminated

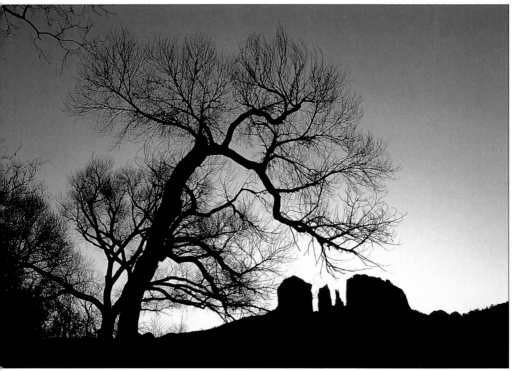

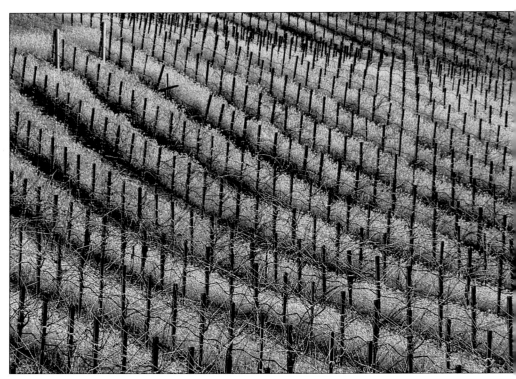

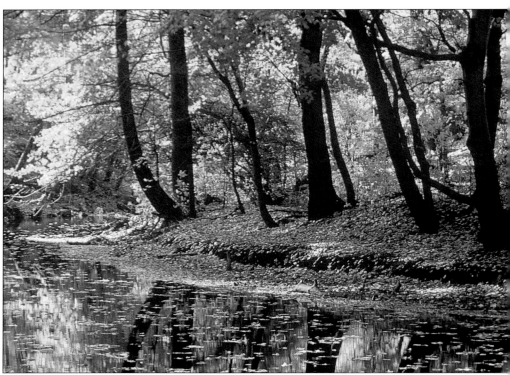

and partly in shadow. This light helps forms and textures stand out.

▪ High-angled light is present at midday, illuminating the subject from overhead and casting short, downward shadows.

▪ Low-angled light is found at the extremes of the day, illuminating the subject from near the horizon and casting long, lateral shadows.

▪ Overcast, diffused light has no direction and is essentially shadowless.

Naturally, each kind of light has advantages and disadvantages that you should take into account as you shoot.

COLOR

The color of light is the least crucial element, although an awareness of its potential can guide you toward more effective use of the available natural light. In general, light takes on cooler tones under a cloud cover and warmer tones when the sun is visible. Sunlight is warmest in color toward sunset, and less so at sunrise. Midday sun is either colorless or slightly blue from the sky's reflection. Remember also that light reflected from surfaces in the environment will influence your image so you might want to enhance or reduce that color with appropriate filters.

Sidelighting brought out the texture in these spring vineyards by creating shadows between the rows. Shooting in California with a Zuiko 50-250mm lens set at f/8 for 1/30 sec. on Fujichrome 100.

Backlight gave the fall foliage in this scene at the New York Botanical Garden in the Bronx, New York, the luminescence of stained glass. Here, I metered the bright leaves and overexposed by 1/2 stop. With a Zuiko 50-250mm lens set at 100mm, I exposed for 1/125 sec. at f/8 on Fujichrome 100.

The green light reflected from the surrounding spring foliage added luminosity to this swan-filled pond in South Carolina. Fujichrome Provia enhanced the green tonalities. Shooting handheld with a Zuiko 50-250mm lens set at 200mm, I exposed at f/5.6 for 1/125 sec.

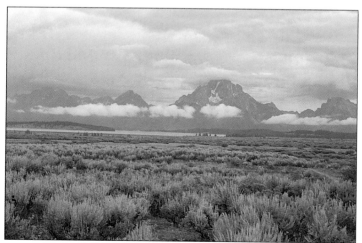

Alpenglow, the pink mountain light that the sun reflects before it rises, bathed this summer landscape in Grand Teton National Park in Wyoming. To enhance the color pink, I overexposed by 1/3 stop. Working with a Zuiko 35-70mm lens set at 35mm, I exposed for 1/4 sec. at f/11 on Fujichrome 100.

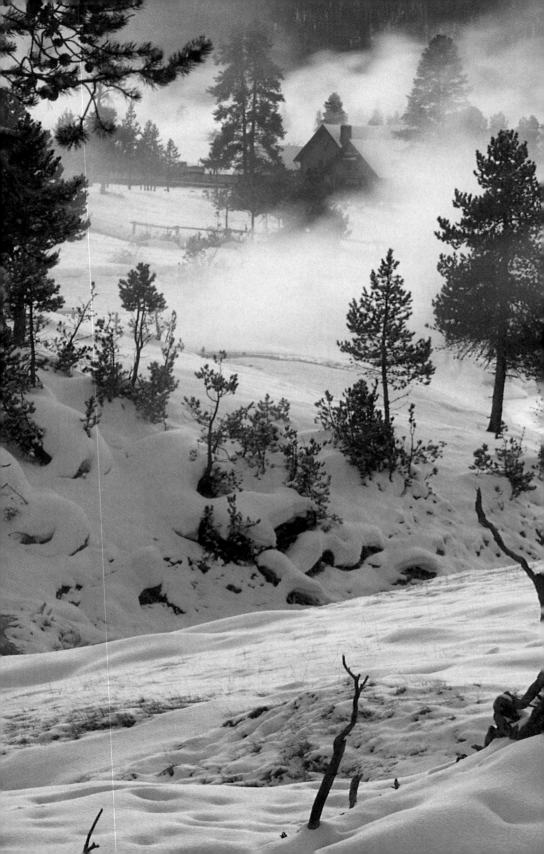

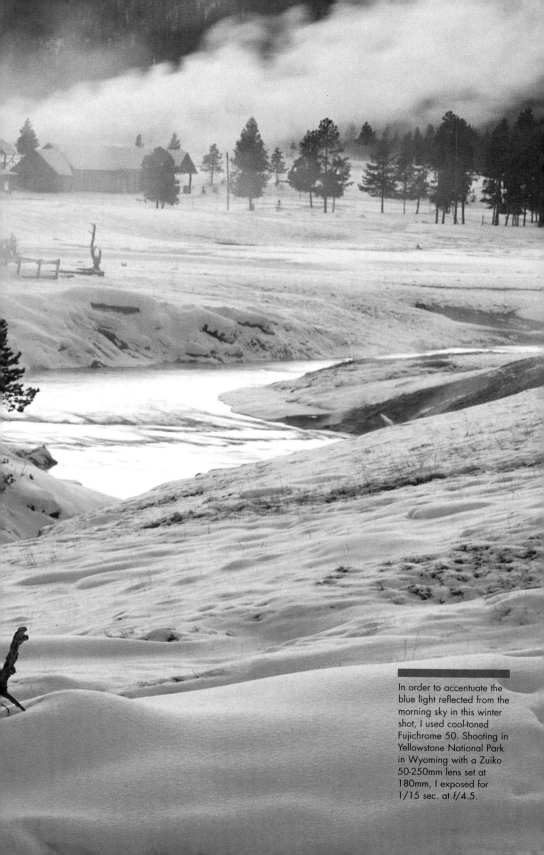

In order to accentuate the blue light reflected from the morning sky in this winter shot, I used cool-toned Fujichrome 50. Shooting in Yellowstone National Park in Wyoming with a Zuiko 50-250mm lens set at 180mm, I exposed for 1/15 sec. at f/4.5.

Soft, diffused light complemented the pastels and made determining exposure simple for this shot of cherry trees at Holland's Keukenhof Garden. With a Zuiko 35-70mm lens set at 35mm, I exposed Fujichrome Velvia for 1/30 sec. at f/11.

Early morning mist is a common spring light found in the Kentucky countryside. So for this shot of the Bernheim Arboretum, I metered the land, not the mist, for accurate exposure. Shooting with a Zuiko 35mm lens, I exposed Fujichrome 100 for 1/8 sec. at f/11.

With these analytic concepts in mind, begin to explore the qualities of light at various times of the day. Try to be outdoors before sunrise and after sunset to take advantage of the pleasing light effects at those times.

SPRING'S RAYS OF FRESHNESS

The hallmark of spring is the ready availability of diffused light. This is the season when mist, fog, and rain are regular visitors, and the wise photographer will take advantage of their soft, lovely effect, as well as occasionally use them as a subject in their own right. This is the perfect light for depicting the fresh, pale pastels of spring.

In addition, spring's soft colors work well with low-angled light, particularly the rays of the early-morning sun. So be sure to get out of the house before dawn if you care to capture this special light. To retain the gentle tender qualities of this light with spring's characteristic colors, spot-meter your subject. This is the best way to obtain an accurate meter reading at all times. For pastels, which have subtle colors, inaccurate exposure might destroy your chances of capturing those delicate colors. Another option is to take a closeup meter reading and then bracket toward overexposure at half-stop intervals up to a full f-stop.

On bright days, be especially careful to retain the pastel tones either by diffusing the sun's light with a screen or white umbrella. A diffusion screen is a piece of white, translucent fabric, such as nylon, mounted in a flexible frame 12 inches in diameter or greater (for your purposes, up to 30 inches would work). The screens come in various densities, calibrated at one f-stop, two f-stops, and three f-stops, depending on how much diffusion you want. You hold the screen between the sun and the subject to diffuse the light.

You can also wait for a cloud to pass in front of the sun before shooting. Unless the cloud is very dark, it would probably reduce exposure a bit, but that shouldn't matter since the cloud would diffuse light that is

After a spring shower in Maine, ordinary subjects, like this rosebud and leaves dotted with rain-drops, become alluring. In this soft, uniform light, I exposed for the middle tones, such as the foliage. Working with a Zuiko 90mm macro lens, I exposed at f/8 for 1/2 sec. on Ektachrome 100 SW.

already quite bright. In any case, you'll be taking a meter reading of the light after it is diffused. Yet another alternative is to look for interesting subjects in the shadow areas of your scene, and work primarily with vignettes and details.

If you want mist or fog to be the primary points of interest in your image, spot-meter the deepest color in your scene, and use that exposure. Another possibility is to meter the white of mist or fog and overexpose up to one f-stop to keep them as white as possible.

Spring photography is enhanced by Kodachrome 25, Ektachrome 100 SW, Fujichrome Velvia, and Agfachrome 50 RSX, the last three being especially suited to misty, foggy conditions.

SUMMER'S BLAZE OF CONTRAST

Summer light can flash with high intensity. Shadows are deep and dark, while hot spots blaze from the shiny surfaces of leaves, rocks, and water. Such high-contrast illumination is one of the hardest for most films to handle well. If you expose for the bright areas, shadows will probably be

I underexposed this sunflower meadow by 1/2 stop in order to dramatically set off the bright summer light against a nearby dark hill. Shooting in Colorado with a Zuiko 35-70mm lens set at 35mm, I exposed Fujichrome 100 for 1/60 sec. at f/11.

Following a summer storm, the sun's rays often form rainbows. Here, I underexposed the gray sky by 1 stop and used a polarizing filter to deepen the colors of the rainbow. Here, I used a Zuiko 50-250mm lens set at 150mm and exposed at f/5.6 on Ektachrome EPP.

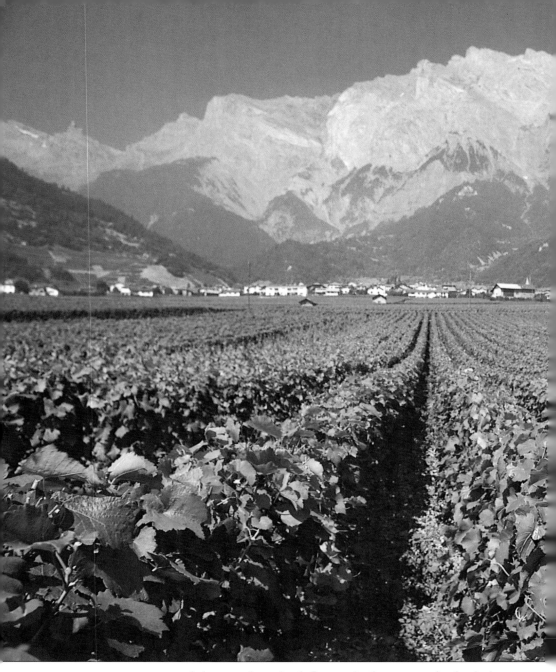

too dark to reveal any detail. Conversely, if you expose for the shadow areas, the bright parts are likely to be bleached out and unpleasant to look at. But you can handle this dilemma several ways.

Compose shots that are entirely in shadow. However, watch for hot spots of bright light in the background and find a way to eliminate them, either by moving so they aren't in the frame or by blocking them with something in the foreground.

Use your flash unit to illuminate subjects in shadow, which might otherwise appear dull and lifeless. The short burst of light from a flash decreases the contrast between the subject and backdrop. However, be

The bright sidelighting in this summer scene required me to underexpose by 3/4 stop from the meter reading on the Alps behind this vineyard in Switzerland. Shooting handheld with a Zuiko 28mm lens, I exposed Kodachrome 64 for 1/60 sec. at f/16.

sure you use your flash unit at partial power so the naturalness of the scene isn't destroyed. Many automatic cameras have a fill-flash mode that is ideal for such situations.

Compose shots that are entirely in sun. Make good use of the light's high intensity, but check that your image won't suffer from having any visible shadows go completely black. Also, work with your flash unit in backlight that can use an extra boost (for complete information about using flash, see our companion volume, *The Field Guide to Photographing Flowers*).

Compose shots that make graphic use of the contrasts. You can also

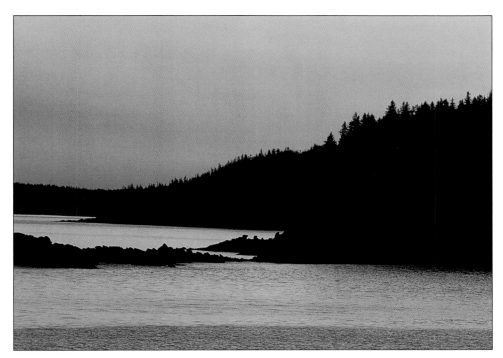

incorporate shadows or silhouettes as abstract or interesting shapes within your frame.

Choose an exposure between the extremes that represents an acceptable compromise. Keep in mind, however, that this is the option with the smallest chance of success and, by the way, the one automatic cameras are most likely to choose. You'll have neither the advantage of saturated colors or meaningful detail in the shadows.

A polarizer is a must for retaining the richness of summer's colors in high-contrast light. Keep one on each lens, and check how it affects reflections and colors in greenery, water, and sky. Also, be sure to keep a lens shade, or sun shade, on each lens to avoid flare, especially for backlight when the sun is low in the sky. The film of choice for reducing contrast is Kodak Ektachrome 100 SW. Other good film options for summertime shooting are Fujichrome Velvia for getting brilliant, saturated colors, and Agfachrome 100 for brightening a dull scene.

Use a spot meter to get the most precise reading possible on your landscapes. Such an exposure reading will be minimally influenced by the extraneous light common on a bright summer day. In fact, take several readings on various parts of the scene, and then decide which exposure settings to use.

In a landscape, you might spot-meter a bright area, such as the sky or water; a middle-range area, such as the vegetation and any rock outcrops; and any large, dark shadows if you want to retain detail in them. Record all readings. If the brightest and darkest areas differ by more than four *f*-stops, you'll have to sacrifice or eliminate one or the other extreme from the composition. Generally, if you have to sacrifice one or the other, let the shadows go dark, and expose for the highlights. Just be sure that the shadows don't dominate the image.

The light of summer storms is also spectacular. As thunder clouds move in, notice how the sun-drenched landscape can look as if it is under

Photographing just before a summer sunrise, I underexposed by 1 stop from the meter reading of the sky to enrich the natural red tones in this Maine coastal scene. Here, I used a Zuiko 50-250mm lens set at 180mm and exposed for 1/2 sec. at f/11 on Ektachrome 100 SW.

A warm-toned polarizing filter added a glow to the low-angled, summer afternoon sidelight on this Colorado mountain meadow. With a Zuiko 35-70mm lens set at 50mm, I exposed for 1/30 sec. at f/16 on Fujichrome Velvia.

Late afternoon sidelighting bathed this deer and its autumn setting in rich, warm colors. Shooting handheld with a Zuiko 50-250mm lens set at 100mm in Great Smoky Mountains National Park, Tennessee, I exposed at f/4.5 for 1/250 sec. on Fujichrome Velvia.

a spotlight. To capture that light contrast, meter the clouds and then underexpose from 1/2 to 1 1/2 stops to darken the sky and help bright foreground areas stand out. And after a summer storm, look for rainbows to photograph. Meter the sky near the rainbow, and underexpose from 1/2 to 1 full stop. In addition, try polarizing the scene to deepen the colors of the rainbow.

The sky tends to wash out on bright, hot days. If you notice a bland, white sky as you're composing an overview shot, either rethink the image so you camouflage the sky with a foreground screen, such as leaf-filled tree branches, or recompose to limit or eliminate the sky by angling your camera down or finding a tighter composition with a telephoto or zoom lens. You also might want to experiment with a graduated neutral-density (ND) filter to balance the bright light of the sky and the somewhat less bright land area.

FALL'S LUMINOUS LUSTER

The glorious golds, reds, and oranges of autumn are all the more lumi-nous in the low-angled light of this season. The sun, low in its arc,

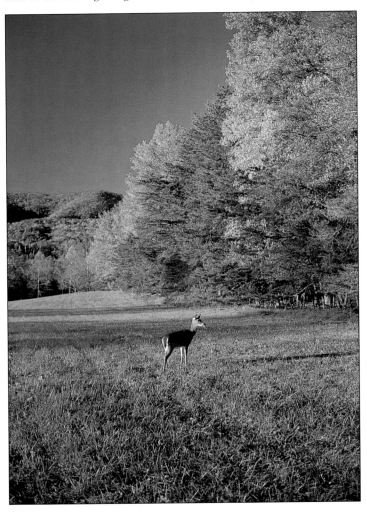

I used an 81B warming filter to accentuate the golden tone of the tall grasses in this natural garden in New Jersey. With a Zuiko 50-250mm lens set at 100mm, I exposed Ektachrome 100 SW for 1/125 sec. at f/8.

Overcast backlighting illuminated this autumn forest in Tennessee. I overexposed by 1/2 stop to brighten the red leaves on this oak tree. Working with a Nikkor 80-200mm lens set at 200mm, I exposed for 1/60 sec. at f/11 on Ektachrome 100 SW.

Winter light can be quite dramatic, casting long shadows that enhance this otherwise undifferentiated shot of the Donald M. Kendall Sculpture Garden at PepsiCo Headquarters in Purchase, New York. With a Zuiko 35-70mm lens set at 35mm, I exposed for 1/250 sec. at f/8 on Kodachrome 25.

To brighten the white of the snow on this misty, overcast winter day at the New York Botanical Garden in the Bronx, New York, I overexposed by 1/2 stop. Shooting with a Zuiko 35-70mm lens set at 35mm, I exposed at f/11 for 1/30 sec. on Kodachrome 25.

To brighten the dim sunrise light behind this silhouette of a white oak tree at Winterthur Garden in Delaware, I took a meter reading of the foreground and overexposed by 1/2 stop. Here, I used a Zuiko 35-70mm lens set at 35mm and exposed Fujichrome Velvia for 1/8 sec. at f/16.

produces a warm light that complements the natural landscape in general and fall foliage in particular. The light is sometimes so radiant that it alone can be the focal point of your image. Look particularly for translucent, backlit subjects toward sunset or brilliant scenes illuminated by the soft, low-angled light of an autumn sunrise. Of course, take advantage of diffused light for capturing fall's wonderful rich colors.

Backlight can be tricky to expose for. The easiest way to achieve accurate exposure is to meter the brightest area, then overexpose 1/2 to 1 full f-stop. The amount of overexposure depends on how much you want to brighten the subject. To saturate fall colors in bright sun, meter the middle tones and underexpose by 1/2 to 1 full f-stop.

However, to shoot foliage up toward a blue sky, meter the foliage and overexpose to capture the backlit effect. For best results, spot-meter or use a telephoto lens to isolate the leaves you want to expose. And polarize to turn the sky a deeper blue. Film choices for fall color are simple. For warm tones, shoot Ektachrome 100 SW. For gaudy, brassy colors, shoot either Fujichrome Velvia or Agfachrome 100.

WINTER'S DELICATE ILLUMINATION

Do as much of your winter nature photography as possible on overcast or misty days. The soft light enables you to bring out all sorts of subtleties, from the muted colors of trees and plants to the movement of water in an icy stream. If you want to capture the motion of the water, use slow film, between ISO 25-50, together with a slow shutter speed, ranging from 1/8 sec. to 1 sec. To reduce contrast in a bright snow scene, use Ektachrome 100 SW or Fujichome 100 Sensia. To increase contrast in dull illumination, use Fujichrome Velvia, Agfachrome 100, or Kodachrome 25.

But winter days can be eye-squinting bright. When they are, they pose all kinds of photographic difficulties. The high-contrast light makes details hard to get, especially in snow or in deep shadows. You might want to experiment with an ND filter to reduce overall brightness. Another possibility is to emphasize the graphic design of the image. And by all means polarize to reduce glare and deepen the blue of the sky.

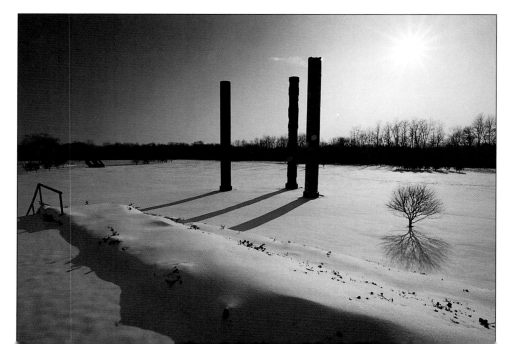

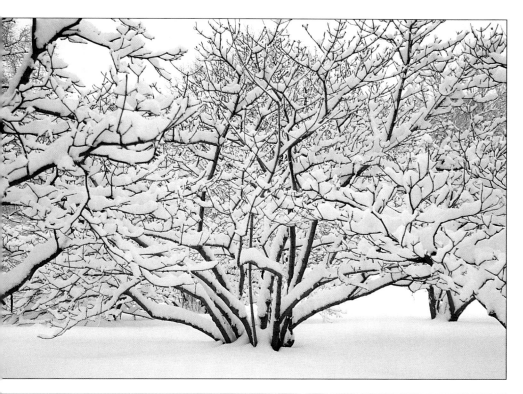

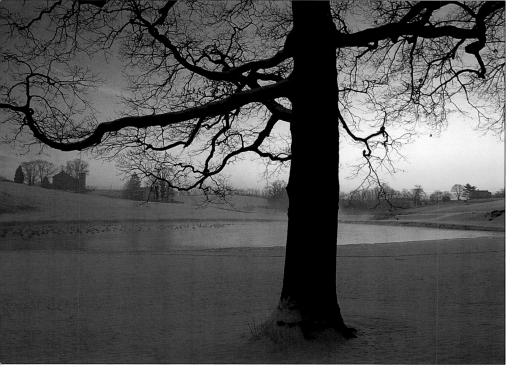

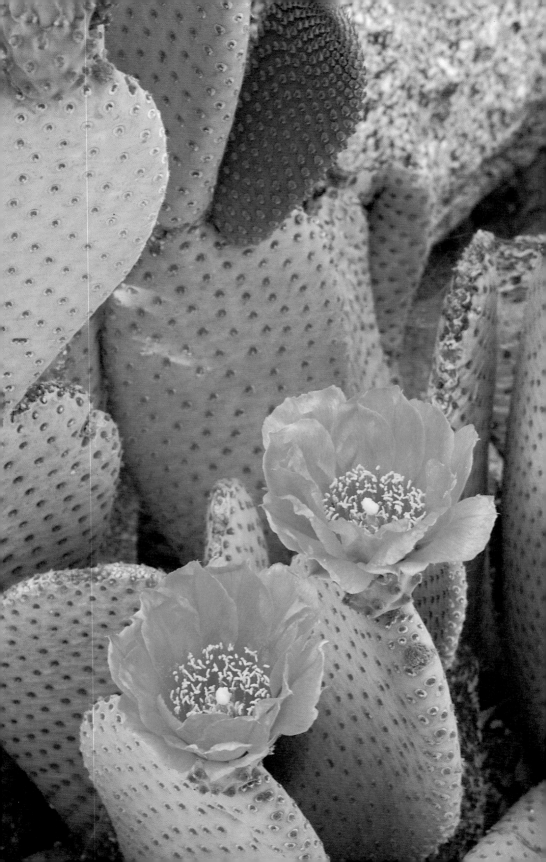

CHAPTER 6

Seasonal Sightings

Spring is the time to find the hot pink flowers of the prickly pear cactus in desert environments. Working with a Zuiko 35mm lens, I exposed Fujichrome 100 for 1/250 sec. at f/5.6.

Eastern woodland wildflowers, as well as colorful azaleas, burst into bloom each spring at Delaware's Winterthur Garden. With a Zuiko 35-70mm lens set at 35mm, I exposed for 1/15 sec. at f/16 on Fujichrome 100.

Each season has its telling signs, events in the cycle of nature that people are still attuned to, even in an age when connections to nature have been severely weakened. You might not notice these signs immediately, but they capture your attention before long. You respond to the sighting of the first robin of spring, the full bloom of a summer rose, the falling of autumn leaves, and the first dusting of snow.

You can sight warblers and other migrating species of birds during spring and fall. Shooting with a Zuiko 350mm lens and a +1.4X teleconverter in Bonaire, I exposed at f/2.8 for 1/125 sec. on Fujichrome Velvia.

Of course, the specific sightings will vary with your location. If you're just starting to photograph seasonal changes, plan to work close to home. This will enable you to venture out often, with your eyes open even when you don't have your camera in hand.

Take a walk around a local nature preserve, park, or other natural areas. Return to the same places over the course of the seasons, going at various times of day and in all kinds of weather to see what kinds of images you can discover.

Don't rush yourself; stop often to pay attention to some small but significant change. For example, new plants might have pushed through the soil or come into bloom. Leaves might be unfurling or changing colors. A different light might illuminate aspects of the scene you didn't notice before, or might make them particularly lovely.

Each time you go back, your eye will review the scene with greater familiarity, as if you were scanning the face of a member of the family or a close friend. You'll become sensitive to nuances that might have eluded you in the past. And you'll probably take particular joy in the small gifts nature has prepared for you.

Take along a notebook and pen to record your sightings by date. Then, the following year, you'll have a sense of when to expect what. As a result, you'll be able to better plan your photographic adventures, with a greater sense of anticipation and looking for specific sightings.

When you are away from home on a photographic trip, find out before you go what you can expect to see in the season of your visit. At national and state parks, rangers can often help you identify the most likely sightings in the area. Another option is to check for and with local naturalists in a chapter of the Audubon Society or Sierra Club. They can often suggest the best places to go and what you can expect to find there. Armed with this knowledge, you are likely to have a much more rewarding excursion than if you went unprepared. Here are a few suggestions about what to look for in each season.

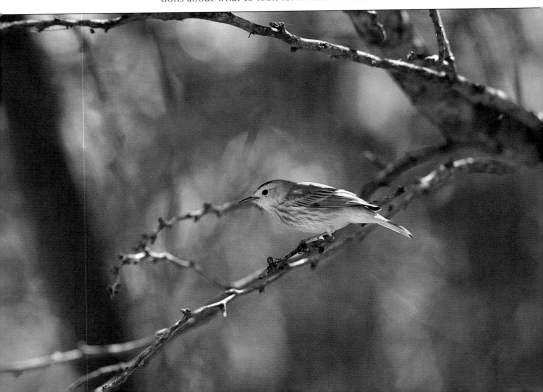

SPRING'S SIGNS OF RESURGENCE

Spring's arrival in temperate-zone locations is marked by the return of migrating birds; the emergence of flowering bulbs, such as crocuses, daffodils, narcissus, tulips, and hyacinths; and the blooming of fruit trees. Woods and meadows reveal native wildflowers too delicate to survive the heat of summer. In arid environments, a desert bloom is likely to carpet the valley floors in early spring, with the fullest bloom coming after a wet winter. Also look for flowering cacti, shrubs, and succulents. In mountainous regions, streams swollen by snow meltoff and waterfalls now cascade over rocky precipices.

The blooms of spring are often short-lived and difficult to time precisely. If you're going far from your home region, call well ahead to check conditions and predictions about a bloom. Once on location, get out often because the bloom can fade quickly, especially if a sudden rain- or windstorm passes through. You should also make some attempts to incorporate flowers that might not have reached their peak yet or are past their prime. Such images take great ingenuity and skill, but they are often more interesting than portraits of model-perfect specimens.

For overviews of the landscape, turn to your wide-angle lens, and come in as close as possible to the specimen in the foreground. This approach is particularly effective in wide-open areas, such as the desert. To make flowering trees or groupings of bulbs appear denser and more colorful, try using a telephoto lens, compressing the space between individual specimens. Floral closeups using a macro lens let you fill the frame with color.

Photographing birds and other wildlife—again, check with a local naturalist to see what you can hope to come across in the area—probably requires a powerful telephoto lens and a mastery of special techniques. (See our companion volume, *The Field Guide to Photographing Birds*, for detailed instructions.) Large wildlife, such as moose and deer, are most

Daffodils and forsythia make cheerful spring companions at the Donald M. Kendall Sculpture Garden at PepsiCo World Headquarters in Purchase, New York. Working with a Zuiko 50-250mm lens set at 200mm, I exposed at f/8 for 1/30 sec. on Kodachrome 25.

visible in feeding areas early in the morning or late in the day. Try to find
a spot that isn't more than 75 feet from the subject and serves as a blind
so you don't disturb the animal as you photograph. A blind is a natural or
handmade structure that hides a photographer from view. Work on
showing the subject engaged in an engaging activity, such as eating,
grooming, or feeding its young. Getting these kinds of shots takes
tremendous determination and patience. It is a worthwhile goal, but not
one you should expect to reach easily or quickly.

SUMMER'S BURST OF BLOOM

As spring ripens into summer, trees fill out: their leaves unfurl and turn a
deeper green. The showy blooms of seaside roses grace beaches, dunes,
and cliffs. Meadows and roadside fields burst with wildflowers, daylilies,
cornflowers, black-eyed Susans, Queen Anne's lace, Indian paintbrush,
and columbine, to name just a few. Wetlands and ponds host irises and
waterlilies at their finest. And insects come into their own, even as other
wildlife tends to retreat.

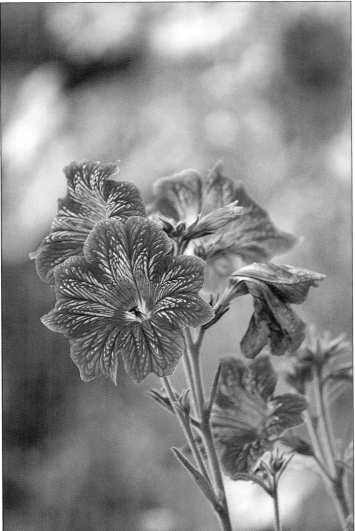

Natural meadows carpet the summer landscape of New Jersey with black-eyed Susans and other wildflowers. Here, I used a Zuiko 35-70mm lens set at 35mm and exposed for 1/15 sec. at f/11 on Fujichrome Velvia.

Annuals reach their peak in summer, gracing many private and public gardens. Shooting at San Francisco's Strybling Arboretum, I used a Zuiko 50-250mm lens set at 250mm to blur out both the foreground and background. I exposed Ektachrome EPP at f/5.6 for 1/500 sec.

Work on developing effective abstract images that combine the multi-colored look of meadows. Practice using a slow shutter speed to create a soft, fuzzy look as flowers sway in a summer breeze. You might want to try a "slice of the scene" effect by using a telephoto lens with a wide-open aperture to limit the depth of field. Also, experiment with floral closeups that blur out the background by using a macro lens at a short distance from the flower.

Water images can yield lovely reflections. Set several goals for yourself: to create effective images that focus entirely on the reflection, to combine the reflection with the scene above, and to remove the reflections with a polarizer to intensify the rest of the scene. For a sharp, well-exposed reflection, focus on the reflection, and expose by metering the highlights in the reflection (but not the glare on the water's surface); bracket by 1/2 stop in each direction. To combine the reflection and surroundings, meter the bright areas in the reflection and on the land. If the reflection and surroundings are within 2 f-stops of one another, expose for the more important subject (presumably the reflection, but not always), and bracket as described above. To remove unwanted reflections and darken the water, such as when shooting waterlilies on a pond, use a polarizer and watch for the effect you want.

Bugs and butterflies can prove a challenge. The operative word is "fast." To successfully photograph these subjects, you'll have to work quickly so use a fast shutter speed and a fast film. A zoom lens will help you compose fast. This is also the time to turn to your electronic flash: the short burst of light will freeze movement with lightning speed. And, unless you are lucky and find a swarm of butterflies happily grazing on a tree, you'll want the added advantage of automatic settings for exposure and, perhaps, focus. These are often "grab shots," which means "Grab it while you can, and refine it if time permits." Don't wait too long between shots, but keep improving the image in any way you can as you keep shooting.

Birds and animals congregate wherever they feed. Early-morning feeding times are best for finding them in their favorite habitats. Be on the lookout for wildlife with their young; ducks with ducklings or deer with fawns are two favorites.

FALL'S MARKS OF MATURITY

As summer yields to fall, flowers fade, grasses turn golden, and trees become the focus of nature's beauty. Migratory birds return, and are now easier to see as trees become bare. The dried, brittle remains of meadow plants and barren tree limbs add textural abundance to nature images. Look especially for pods that have burst open, revealing the delicate threads of the seed parachutes. Combine the warm-toned foliage with the neutral grays of rocks or the deep blue of the sky. And let the richly colored scenes become lusher still in the glow of the low autumn sun.

Bring out the textures of the season by keeping images as sharp as possible. Use a small aperture of f/11 to increase depth of field, set your shutter speed to 1/125 sec. or faster to counteract any autumn winds, and focus with extreme precision. You might need to use a fast film rated ISO 400 to manage a small f-stop and a fast shutter speed.

Continue to incorporate reflections; during this season, reflections amplify the intensity of warm tonalities on land. Experiment with symmetrical and asymmetrical compositions, with diffusion or soft-focus filters, and with warming filters. You'll get the most brilliant colors in the afternoon as the sun drops to a low angle that can produce stunning backlight and polarizes well.

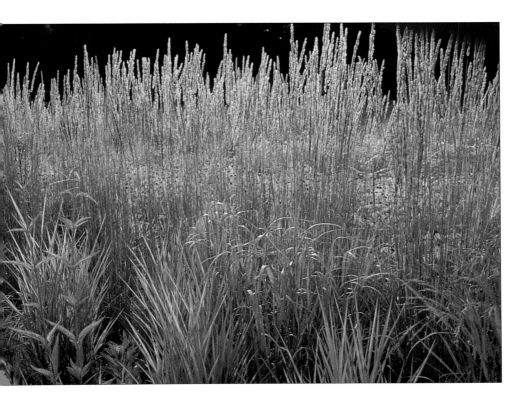

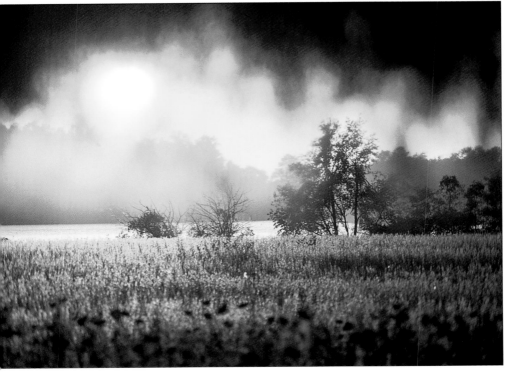

On overcast days, venture into a wooded area to capture the carpet of fallen leaves and needles at the feet of a stand of trees. Pay special attention to the trees themselves, looking down, up, and across for a wide variety of images. Try your wide-angle lenses for panoramic compositions or your telephoto lenses for a flat, abstract design. Then come in with your macro lens for a closeup look at the bark.

WINTER'S NATURAL WONDERS

While nature might appear dormant in winter, it is far from asleep. Animals huddle near sources of food and water, making them easier to spot. Water takes on strange shapes as it turns to ice. Trees emerge as stately sentinels, their branches reaching skyward with a crispness and clarity they lack in the other seasons. Silhouettes of trees and their shadows are particularly alluring in snow or against a fiery winter sky.

For wildlife shots, look for ducks and geese that spend the winter in your area. You can find herds of bison, longhorn sheep, and other large game in many national parks.

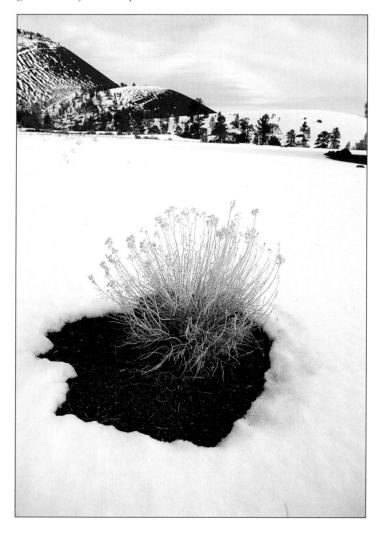

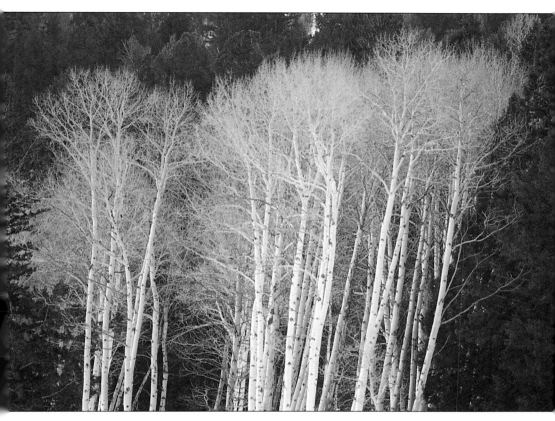

Even shy creatures like foxes can be glimpsed coming out of hiding to find something to eat. Ask a local naturalist what you are likely to find in the vicinity. But remember, you aren't likely to get shots worth looking at unless you can get close enough to the creatures and use a telephoto lens with a focal length of 300mm or more.

Think of your winter scenes as basically black and white. Emphasize the strong, graphic qualities of lines, shapes, and textures that come to the fore. Seek out interesting details, such as berries in snow, snow on tree bark, and frost or ice on leaves and grasses. The monochromatic effect can be quite compelling, especially if it is interrupted with a touch of color here and there. And diffused light makes determining exposure relatively easy, though you should bracket toward overexposure when shooting broad areas of snow. With its monochromatic tonalities and visible textures, winter is the ideal time to hone your skills in abstraction.

Look closely at frozen vegetation, tree bark, snow-covered hillsides, and other subjects for their potential as purely abstract images. The stronger the graphic design, the more effective your abstract will be. For some unusual images, perhaps verging on the abstract, check streams, waterfalls, or seaside locations for ice formations. The texture and shape of ice can be an interesting addition to any scene. For the tried and true, return to familiar territory to show it under a dusting or blanket of snow. The transformation will be sufficiently new to be worth a shot.

Winter aspen trees created a lacy, monochromatic subject against this dark, shadowy backdrop at Yellowstone National Park in Wyoming. Shooting handheld with a Zuiko 50-250mm lens set at 250mm, I exposed Kodachrome 64 for 1/125 sec. at f/5.6.

Index

Abstractions, 82-83
Advanced Photo System (APS), 40, 42
Aesthetics, 16, 19, 22
Agfachrome, 108
Aperture-priority mode, 31
Aperture setting, 31, 33, 35, 50, 52

Backlight, 93, 100, 103, 115
Ball-joint head, 64
Bracketing, 64, 87, 90

Cable release, 65
Camera bag, 63
Cameras
 metering system in, 31
 selecting, 39-42
Center-weighted metering, 31
Clothing, winter, 69
Color, 85-95
 fall, 90-93
 and film choice, 46, 49, 89
 and light, 86, 103-6
 rendition, 49, 86-87
 spring, 87-89
 summer, 89-90
 winter, 93-95
Composition, 71-83
 abstractions, 82-83
 filling frame, 81-82
 format, 73, 74
 lines and shapes, 75-79
 overviews, 73
 patterns and textures, 74, 79-81
 vignettes, 73-75
Contrast, and film selection, 49

Depth of field, 12, 35
Detail shots, 75
Diffused light, 87, 103, 106, 108
Documentation purpose, 16

Ektachrome, 46, 49, 50, 52, 90, 93, 94,
 108, 113, 116
Equipment, 29-69
 basics, 30-37
 cameras, 39-42
 care and maintenance of, 66, 68-69
 fear of, 30
 films, 46-52
 filters, 54-63
 lenses, 42-45
 miscellaneous, 63-66
 testing, 37-38

Fall
 colors, 90-93
 equipment care in, 69
 light, 114-16
 signs of, 124-26

Film
 and color, 46, 49, 89
 protection from heat, 68
 pushing, 52
 selecting, 46-49
 speed, 50, 52
Filters, 103
 neutral-density, 55, 58, 59, 62, 114
 polarizing, 54-55, 56, 57, 89, 90,
 93, 113
 skylight, 66, 68
 soft-focus, 62-63
 warming, 59, 60, 62, 90, 115
Flash, 65, 66, 110-11
Focus, 35, 37
Foggy conditions, 108
Format, 73, 74
Framing, 73-75, 81-82
Frontlight, 100
f-stop, 33
Fujichrome, 46, 48, 49, 52, 90, 93, 95,
 108, 113, 116

ISO (International Standards Organ-
 ization), 50

Journal keeping, 12, 26

Kodachrome, 46, 49, 52, 90, 95, 108, 116

Lenses, 42-45, 93
Lens flare, 65
Lens shade, 63, 65, 113
Light, 97-117
 and color, 86, 87, 103-6
 direction of, 100-3
 fall, 114-16
 intensity, 98-100
 spring, 106-8
 summer, 108-14
 winter, 116-17
Lines and shapes, 75-79

Macro lens, 45
Matrix metering, 31
Medium-format cameras, 39
Mentor, photographic, 22
Metering systems, 30-31
Monochromatic effect, 127
Mood, 16

Neutral-density filter, 55, 58, 59, 62, 114

Overexposure, 87
Overviews, 73, 121

Patterns, 74, 79-81
Plastic bags, 66
Point-and-shoot cameras, 40, 42

Polarizer, 54-55, 56, 57, 89, 90, 93, 113

Reflected light, 103
Reflections, 124

Seasons
 colors of, 90-95
 equipment care in, 66, 68-69
 light of, 114-17
 observant eye for, 10, 12
 photographic vision of, 12, 15
 purpose in photographing, 15-19
 revisiting locations, 26
 signs of, 119-27
 spirit of, 19-22
 See also specific season
Shapes and lines, 75-79
Shutter speed, 31, 35, 50, 52
Shutter-speed priority mode, 31
Sidelight, 100, 103, 111, 114
Sky, 81-82, 114
Skylight filter, 66, 68
Snow, 94-95, 116
Soft-focus filter, 62-63
Spot metering, 31, 65, 113
Spring
 colors, 87-89
 equipment care in, 66, 68
 light, 106-8
 signs of, 121-22
Style, distinctive, 16
Subjects, photogenic, 72
Summer
 colors, 89-90
 equipment care in, 68-69
 light, 108-14
 signs of, 122-24
Sunset, 62, 90, 91, 124

Telephoto lens, 45, 93
Textures, 74, 79-81
35mm SLR cameras, 39
Tonality, film, 46, 49
Tripod, 64, 65

Vignettes, 73

Warming filters, 59, 60, 62, 90, 115
Water, 116, 124
Weather conditions, shooting in, 66
Wide-angle lens, 42, 121
Wildlife, 121-22, 124, 126-27
Winter
 colors, 93-95
 equipment care in, 69
 light, 116-17
 signs of, 126-27

Zoom lens, 42, 44